Techniques of
DRAWING

Fred Gettings

Orbis Publishing, London

Title page
Harold Gilman *The Factories, Leeds*

All illustrations from the Victoria and Albert Museum,
London, are Crown Copyright.

© 1969 by Fred Gettings
First published in Great Britain by Studio Vista Limited,
London 1969
Reprinted by Orbis Publishing Limited, London 1981

Printed in Great Britain

ISBN 0-85613-383-3

£5.95

Contents

分而爲

And now we come to the question, 'What is drawing?' Strange such a question should have to be asked. But some of us have forgotten.

WALTER RICHARD SICKERT

A Free House Macmillan & Co. Ltd

1 The Chinese character *Wei*

2 Rembrandt (1606-1669) *An Elephant* 1637, black chalk. British Museum

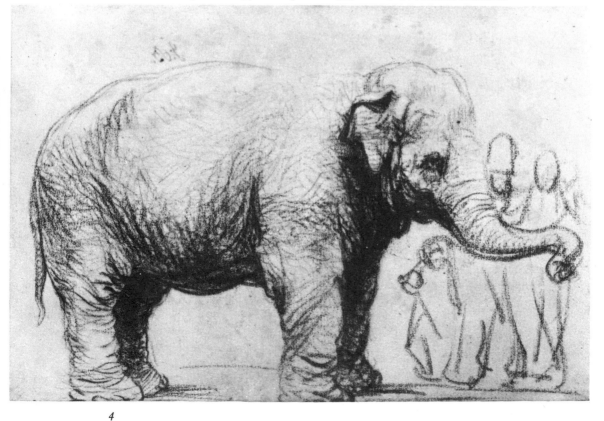

The anatomy of a drawing

Before beginning to draw we must learn something about the anatomy of drawings. Only then may we begin to draw with any real meaning.

Take any drawing, and any symbol or graphic, and compare them. Take perhaps the black chalk drawing of an elephant (plate 2) which Rembrandt made in 1637, a modern biro drawing by a child of the same manner of beast (plate 3), and a Chinese word, the character *Wei* (plate 1). They all have something in common. They are all drawn with some distinct purpose or artistic intention, with the aim of setting down an idea; they all possess, in a word, *content*. They are all drawn in a particular way, with a certain linear structure, with a regard for the conventions which must be observed when recording non-linear ideas in terms of line on paper, a certain style of expression, which may be condensed to the one word *form*. They are all drawn with some instrument or material which leaves a recording mark – material such as ink or chalk and so on, which we call a *medium*. In fact, the drawings each have the triad of content, form and medium in common.

3 Tiffany Gettings, aged 4: *Elephant and Trees* biro

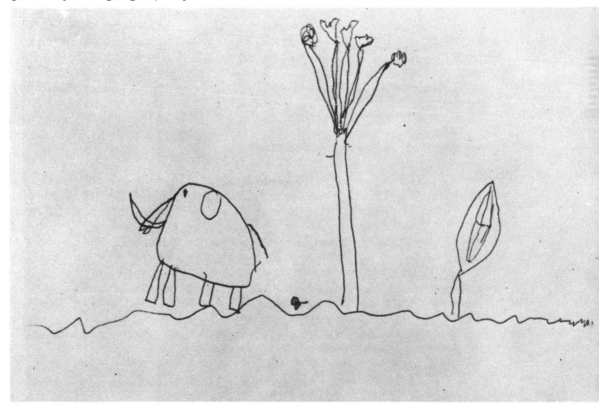

This triad is found in every single drawing, sign or symbol, from the prehistoric cave graffiti to the Raphael cartoons. Every drawing has content, which means more than merely a subject; every drawing has form, which is considerably more than its structure of lines; and, of course, every drawing has to be executed in some medium or other. This is the basic anatomy of a drawing, however complex or however simple it may appear to be.

In the Rembrandt elephant we see a fine relationship between these three qualities. The medium of chalk has been applied like chalk – its special softness has been preserved in the feather-light strokes: the integrity of the medium has been respected; every stroke looks like chalk, and not like pencil or cheese. The form is excellent, and all the different spatial and linear elements have been related together, so that the play of light and shade has been subordinated to a unifying whole which explains the rotund form of the elephant and at the same time expresses its weight. The content of the drawing is especially satisfying, for although it suggests graphically all the characteristics we might expect in an elephant which has been seen and examined by an acute observer, the drawing somehow transcends the particular elephant, and becomes more than a picture of an elephant – it conveys the slow movement and weight of the cumbersome beast, the flaccidity of the loose skin about the legs, the very texture of the hide, while something of what might be called the 'soul' of the elephant resides in the eyes – a slightly brutish yet distinctly philosophic boredom, which is common to all captive animals. In the tension around the mouth, we get a sensation almost of amusement at its own predicament. Its content could well be summed up by what Aldous Huxley might have called 'elephantness'.

With the child's drawing we are on a different level. It is quite different from Rembrandt's elephant. The child was no doubt amusing herself, 'exercising her eidetic faculties' as they say in art schools – being caught up in the wonder of this strange creature which is so weirdly differentiated from all other creatures by the possession of a long nose and a pair of tusks. She employs the minimum of lines, and selects what she considers to be the essentials of the beast: the trunk and tusks, and the four solid legs, unwittingly recalling the mediaeval bestiary elephants who also had trunks, tusks, and four legs – legs so solid that they had no knee joints, and were thus easy prey for the ivory collectors.*

In the child's drawing we find no thought for the rich texture of hide, for the skeletal structure of the inner beast; the child has not yet learned to concern herself with such things. She does not yet require the world of art to correspond to the world of reality – in fact, like all children, she is still exploring the world of reality through the practice of drawing. 'An elephant is an animal with a long trunk' is really what she is saying. She is wanting to differentiate an elephant from all other animals, to catch its essential character, caring not one jot for its soul. So in her drawing we see a curious emphasis on content. This involvement with content at the expense of both form and medium is an artistic involvement which is possible only for very young children and very great artists, since both groups are interested in finding out what makes a thing tick in its own particular way.

* Since the elephants had no knee joints the ivory collectors had only to induce the beasts to fall over in order to capture them, for once the elephant was flat on the ground it could not get up again!

4 Ku K'ai-Chih (c.344-406) Detail from the scroll *Admonitions of the Instructress to the Ladies in the Palace c.232-300*, ink on silk. British Museum

Of course, form and medium are by no means absent from the drawing, but they arise spontaneously, with the kind of delightful innocence and economy of expression which it is hard to capture intentionally.

Well, so far so good: we have before us two drawings of an elephant, one of which is saying 'elephantness', and one of which is saying 'an elephant is a big animal with four legs at each corner, and an enormous trunk and two tusks'. The meanings, and therefore the contents, of the two drawings are quite different, because the intentions of the two artists were different.

In the third of our drawings, the Chinese character *Wei*, we find yet another combination of the triad. This character *Wei* is an elephant also – or, more precisely, it is a picture of an elephant being led by a man. Originally all Chinese words were set down as drawings, so that even today, after some four thousand years and several radical changes in writing techniques, many Chinese words still retain more than vestiges of their pictorial roots. *Wei* is quite a good example of this. In ancient times, when a scribe wanted to write 'elephant', he drew an elephant, thus: 象 . He drew with a kind of up-right fountain-pen which gave an even width to his drawn line, but later on he took to using a brush, which was easier to control on the silk and newly-invented paper used in China nearly two thousand years ago. This use of the brush meant that the form of the written character had to change, as the brush left strokes which were not of even thickness, and the supple hairs of the brush could not always make the same forms as easily as the fountain pen. In this way the original character, which is a picture of an elephant being led by a hand (為), and which is therefore a statement in pictures of the idea of someone leading, of someone in control, of *doing* something, and, by extension, *active*, became 為 , the modern *Wei*.

The important thing about this Chinese elephant is that the content of the drawing is minimal. A student of Chinese etymology would be able to explain its form and origin, but the average Chinese reader would simply know the meaning of the *Wei* character and certainly not equate its form with an elephant. The content is therefore relatively unimportant – it scarcely exists. The form, however, is quite a different matter. The form is very important indeed to the Chinese. The Chinese delight in good calligraphy, which is after all, for them, an extension of good drawing. In each of their texts (such as the one by Ku K'ai-Chih in plate 4) the balance of white paper or silk against

7

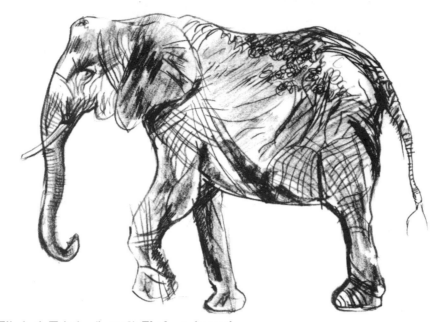

5 Elisabeth Trimby (b.1948) *Elephant* charcoal

the black ink, the textures left by the brush as the characters are drawn, the areas of text against the background of silk or paper, and the placing of each of the individual characters within the framework of this block, are all of utmost importance to the Chinese. Indeed, so important is this aesthetic quality, the beauty and life of the individual strokes, the balance of the characters within the body of text as a whole, that there was a period (at the beginning of our own Christian era) when certain Chinese *literati* considered themselves dishonoured if anyone could actually read what they had written. The form was the really important thing.

One thing we may see from all this is that what is Chinese to us, which is to say 'beyond our comprehension', may be meaningful to someone who has been trained to appreciate the finer points of a calligraphic style. It is immediately evident to us that one may be trained to see form, and from this to read its meaning. This important truth stands behind all visual arts, and it is of quite incredible importance, yet many artists tend to ignore it, and fail to see that it is just as necessary to learn to 'read' art as it is to learn to read words in order to understand books. Just as a writer must learn how to handle words, which are the symbols of his craft, so must an artist learn how to handle form: he can only express himself, which is to say, bring meaningful content to his works, by being in complete mastery of his form, the language of graphics. The implications of this will unfold as we study drawing and drawings.

After studying these three drawings of elephants, we should be in a position to try our hands at one or two practical exercises. Theory and practice must go hand in hand when one is learning to draw. Our aim, perhaps should be to draw as well as Rembrandt. Notice, however, that I do not say *like* Rembrandt, but 'as well as'. We live in the twentieth century, not in the seventeenth, and we should want to draw like ourselves. On the other hand, there is nothing wrong with wanting to be able to draw on the same level as Rembrandt, with the same sureness, technical proficiency, with the same accuracy, and with the same perceptual grasp. However, we must start from the only point we can start from – where we are.

Draw an elephant. Zoos are good places for finding elephants, but being

6 Christopher Blow (b.1949) photograph of elephant

alive, they don't keep still, and in any case if you so much as open your sketchpad in a zoo the tradition is that you'll be surrounded by a mob of children. So, for the moment, for this particular set of experiments, you may find museums are the best places for your elephants – these hold still, and most children keep their distance. In any case, this elephant should be drawn in rather a special way, with time for reflection, and the stiller the elephant is, the better.

First examine the Rembrandt chalk drawing carefully and then list three characteristics in it which appeal to you. These might be the feeling of solidity which the drawing imparts, or the interesting skin texture, or the underlying bone-structure. Make your own list, however. Your aim will be to make three separate drawings of the elephant and in each one to give a particular emphasis to one of the qualities which you found yourself admiring in the Rembrandt. We are not concerned with producing pretty drawings of elephants – we are concerned with having a clear aim in mind, and executing that aim. Perhaps the aim is to draw the skin texture in order to reveal its fascinating surface, as was the aim of the art student who drew the picture of the elephant in plate 5. Perhaps your aim is to impart a sense of weight, and you are faced with the apparent contradiction of somehow stamping a three-dimensional image on a two-dimensional surface.

Struggle along as best you can with the three drawings, and when you have completed them, whether you are satisfied with them or not, put them away in a portfolio for a short while – perhaps for a week or so – and then look at them once again. You will remember what your purpose was in making these drawings, and you should be able to judge how well you achieved this aim. If you find that you are not satisfied with what you did, then look once more at the Rembrandt elephant, or indeed at any good drawings of elephants, and try to find out where you went wrong. In drawing the skin texture, did you allow a sufficient variety of pressures to your pen and pencil, and did you trace the structures of the lines themselves as they snaked around the contours of the body (see plate 6), or did you merely hint at this relationship between the texture and the form? Compare your drawing with those of the masters as objectively as you can. This should inspire you to start again.

9

If, however, you find that you are well satisfied with the experiments with the three drawings, then you must go a step further, and attempt to combine two of the qualities which you studied separately into one single drawing. Sit before your model once more, and study these two qualities from life: really look at that elephant, at its structure, surface, weight and beauty, and then try to incorporate two qualities only into your drawing. Make sure that your aim is clear before you start to draw.

Now look at the pen drawing of an elephant by Gaudier-Brzeska (plate 7), which conveys something quite different from the one done by Rembrandt. Although the way in which the hide hangs over the legs, and the wrinkles around the eyes, suggest the flabby nature of the leathery skin, there is no real interest in the texture of the elephant, and there is no real concern with its solidity. The drawing has grown, as it were, out of a few simple movements of the pen charged with its green ink, and these calligraphic movements have imparted a lovely simple rhythm to the whole design. Yet the main interest of the artist was not his rhythm: there can be no doubt that he was really interested in expressing the *age* of the creature in as simple a way as possible. Not only is the trunk flaccid, as though the elephant can no longer give it a fuse of life, but the two front legs appear to be buckling as though the body is much too heavy for these weak props, and the service of the trunk is required as an insubstantial fifth leg. The drawing is in fact entitled *Old Elephant*. The really fascinating thing about this masterly drawing is the facial expression, which is given form through the eyes and mouth. The eye is almost the first thing which strikes one, for it is emphasized both in tone and linear structure, standing out amongst the single effortless lines like a knot in a piece of cedar wood. Yet it is not just an eye – it is a sad and aged eye,

7 Gaudier-Brzeska (1891-1915) *An Old Elephant* pen and green ink. Victoria and Albert Museum

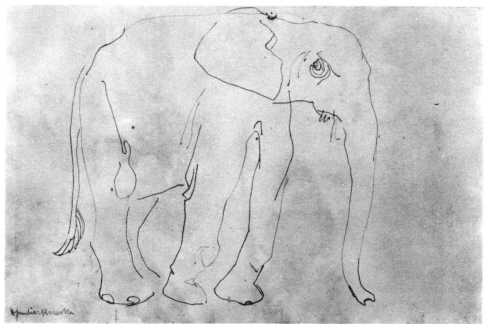

much as the mouth is a sad disillusioned mouth, if elephants may be disillusioned. With the aid of a few easy strokes we find ourselves presented with movement and structure in a harmonious whole. The bones sheathed in the flesh – especially those of the rear leg – can almost be felt, despite the paucity of line, and yet we have also what may be called a 'psychological tension' in the spirit of the elephant. Gaudier-Brzeska was able to draw this old elephant so well and with such apparent ease because he had looked at elephants, observed their salient features, and made himself clear about what he wanted to put in his drawing. He observed how the old animal shuffled along, he saw the qualities in its mouth and eyes, and he sorted out for himself how best to express these in terms of line. His main subject was the age of the beast, yet in order to express this he had to incorporate into his drawing the feeling of weight, bone structure, slowness and inertia. It is quite a different drawing from the one by Rembrandt for the same reasons that the child's drawing is different from both – because the artist was interested in quite different things. The contents of their drawings are meant to be different.

Perhaps now you will be able to see something about drawing, about the importance of analyzing the subject, of looking at what you are drawing and relating what you see to what you wish to express. You will also understand, no doubt, that you are not learning how to draw elephants: you are learning how to draw!

We would almost have finished with elephants for the moment, were it not for the Chinese character *Wei*, but our examination of this will lead us into quite another field of drawing – towards the abstract. The abstract is not something which is so separate from drawing from life as most people think. An 'abstract' line is just as much a reflection of the artist's sensibility as a 'descriptive' line, and as the artist improves his ability to draw descriptive line so does he improve his ability to draw abstract line. If you honestly want to see how much an abstract mark made by a brush or a pencil reveals the artistic ability and expression of the artist, try a very simple experiment at this point. Fill a sheet of paper with abstract marks, doodles and so on, using a brush or a pen. Put the results away into a folder and do not look at them until you have completed all the experiments in this chapter. By the time you have completed these experiments you will have improved your drawing ability, and you will be able to see to what extent your ability to draw (both from reality and abstractly) has improved, and also just how much your study of descriptive drawing has improved your ability to draw abstractly.

There is really no such thing as an abstract drawing. Even a single line placed casually on a sheet of paper changes that sheet of paper and conveys something. What to us may be sixty or so abstract brush shapes (plate 4), are charged with real significance for the Chinese; what may appear to be a blodge of ink and a few bad scratchings of carbon may be full of emotional significance for someone who knows about drawing. As Piet Mondrian, one of the most intellectual of modern artists, said, 'everyone knows that even a single line may convey an emotion'.

So now back to the abstract *Wei*. The form of the elephant has almost disappeared, but the idea, if slightly distorted, lingers on. *Wei* is not an abstract mark to the Chinese, but it is to us, and this is the important point. Try to make some abstract graphics in the manner of Chinese characters,

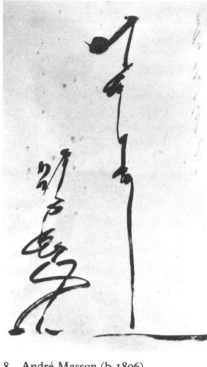

8 André Masson (b.1896)
 Suppliante 1957, brush and ink.
 Galerie Louise Leiris, Paris

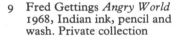

9 Fred Gettings *Angry World*
 1968, Indian ink, pencil and
 wash. Private collection

though entirely devoid of meaning. You may use a brush, like the Chinese,
or you may use a pencil, a crayon or a scrubbing brush, if the spirit takes you.
Draw about six abstract 'characters'. Try to avoid basing them too obviously
on the Chinese; your aim is to invent, not to copy, and so these must be your
own.

It is difficult to invent. Above all, it is difficult to invent shapes and
characters which do not immediately take on a meaning of their own. We all
know how we 'see' faces, dragons and all manner of fanciful creatures in the
clouds, in wallpaper patterns or in accidental textures: this is because the
mind abhors a vacuum. The mind does create 'meaningful' things from the
most unlikely and unmeaningful shapes, as all psychologists know, and as all
artists have known from the beginning of art – and indeed the first cave artists
would sometimes add a few deft lines to such 'meaningful' shapes as they saw
in rocks or pebble formations in order to make their presence more apparent.
While you are working at your abstract calligrams you must be on guard
against this. Try to keep your shapes devoid of meaning, abstracted from
reality, and not obviously related to any real form.

Your other aim is to make them beautiful.

This brings us to a most difficult point. Beauty is an unfortunate word; it
presents an old semantic problem. The existence of the word suggests that

10 Fred Gettings experimental abstracts, 1968, Indian ink

11 Bernard Requichot *Dessin* 1960, ink and white gouache. Collection Daniel Cordier

the thing itself exists, and although 'beauty is in the eye of the beholder' is a common enough adage, few people really believe this, for they still talk about beautiful things. Beauty is as fleeting and inconstant as an emotion. It is related to love, but all we need say at this point is that you must try to make each of your six shapes beautiful *for you*, so that when you look at them you feel that they are beautiful. You are to be the measure of your own work.

Plate 8 is an example of meaningless calligraphy which André Masson produced while inspired by Chinese writing. The fact that Masson is a fine draughtsman permitted him to produce such exciting abstract shapes: they reflect his inner world, just as your shapes will reflect your inner world. Try inventing similar forms. You might try something in the manner of the experimental graphics in plate 10; or start from your own handwriting, and create some abstract forms. My own abstract (plate 9), or Bernard Requichot's superb drawing (plate 11) may give you some inspiration, for in both of these the forms appear at some points to merge into the abstract lines, and at other points to glide out of them, so that there is an altercation between the written forms and the abstract lines. Although this kind of abstract work is difficult to handle, there is much enjoyment to be experienced in it, and a great deal to learn about how much drawing is an extension of writing, and vice versa.

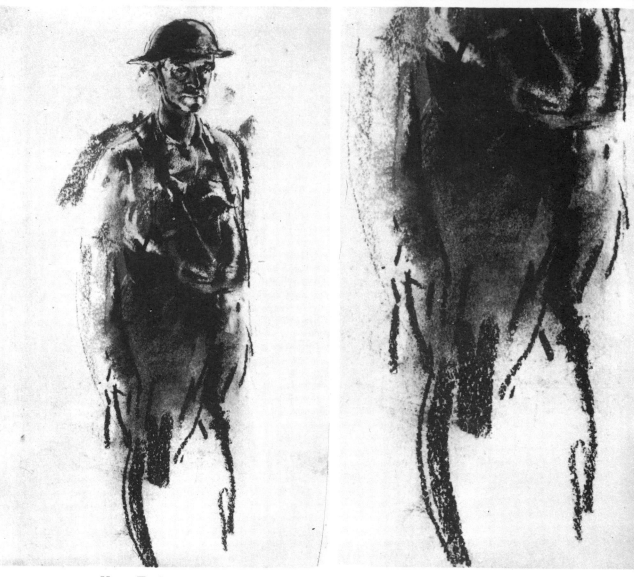

12 Henry Tonks (1862-1937) *Study of an Army Officer* chalks. Victoria and Albert Museum
13 *Right* Detail from plate 12 *Study of an Army Officer*

Once you have finished your six shapes, or your abstract calligrams, put
them aside for a while. You will have learned two things at least as a result of
this experiment: first that it is difficult to invent abstract shapes, to summon
them out of nowhere, as it were; and secondly that you are bad at drawing
abstractly. This is merely because you cannot draw from life. The two go
hand in hand: both 'abstract' and 'descriptive' forms are related to the under-
standing of the artist, so that as the understanding moves ahead, so does the
ability to draw abstract and real forms, until that glorious day (which few
artists ever see) when the abstract and the real merge together, and there is
no real difference between the abstract lines which trace the form and that
form itself; when the lines which describe the back of an elephant are part of
the real quality of that elephant itself; or when there is no difference between
the slashes and rubbings of abstract chalk marks (plate 13), and the inner
essence of a soldier which they form (plate 12) – when the writing is the
drawing, and the drawing itself is a piece of reality!

However, to return to the point of these experiments in practical drawing,

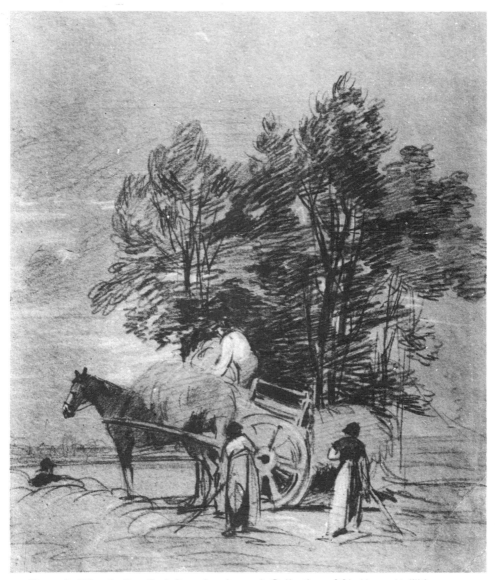

14 Peter de Wint (1784-1849) *Drawing* charcoal. Collection of Sir Harry F. Wilson

we must again observe that all drawings, and indeed all works of art, have a content, form and medium. You will have noticed that your main struggle so far has been with form, since in the first set of experiments your subject was chosen for you, and you had to draw an elephant whether you wanted to or not, and furthermore you had to limit the content intentionally as part of the exercise. In the later experiments with abstract graphics you found yourself grappling mainly with form, since the content was almost entirely absent. So it is evident that you have so far been studying form – to the extent that form may ever be said to exist independently of content and medium.

The next experiment is aimed at helping you to bridge the gap between the abstract and descriptive forms a little more easily. This time choose your own subject. You might like to draw a vase of flowers, a few cows in a field, or a dog. The subject itself is not important. Your drawing must be as accurate a portrayal of the subject as you can possibly make – if you are doing a landscape, then it must be topographically accurate and imbued with the feeling of that particular landscape, perhaps like the one by de Wint in plate 14. If

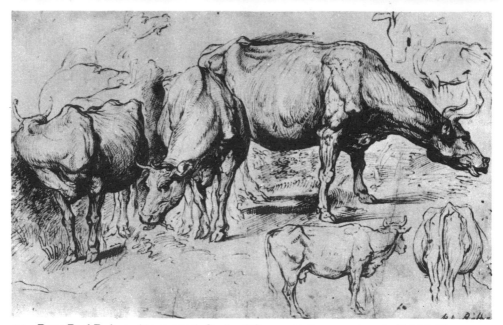

15 Peter Paul Rubens (1577-1640) *Study of Cows c.*1636, pen and sepia. British Museum

you have chosen to draw a few cows, then your pen lines should be as accurately placed as those of Rubens in plate 15, and the forms of your cows just as accurate. If you have chosen to draw a spray of leaves or flowers, then your drawing should be as precise as that of Taylor's *Marsh Mallow* (plate 16). Accuracy of descriptive form must be to the fore.

When this drawing is completed you must make another drawing of the same subject, but this time you are to make it as abstract as you possibly can, yet leaving it recognizably the subject. Of course, your abstract treatment must somehow be an exploration of the subject itself – in your landscape you must catch the different qualities of foliage (even at a distance the leaves of the oak look quite different from elm leaves, or sycamore) in a few splashes of ink. If your first descriptively analytic drawing had been of an industrial landscape, then your second 'abstract' version may be on the lines of the one by Gilman (plate 18), with the human figures all but dehumanized to four or five heavy lines, and the pattern of factories behind reduced to a series of abstract shapes filled with dotted textures. If your chosen subject was a dog, then you must try to catch the essential 'dogginess' of the creature with a few strokes of the pen or a sweep of a heavily charged brush. Look at the way in which Bonnard succeeded in picturing seven different dogs with the absolute minimum of graphic means, catching the inner essence of each (plate 17). In this little masterpiece we can feel the canine spirit, the movement and that almost childish frolic which occurs whenever a group of dogs meet together in the street. Bonnard has watched dogs and understands their nature. You too must try to reduce your impressions of the subject to a few abstract lines, as part of this experiment.

By now you should have a better idea as to what a drawing is. Try to bear in mind the triadic nature of a drawing as you read the next few chapters, for this will help you both in your appreciation of drawings and in your practical approach to drawing itself. Try also to understand the relationship between abstract and descriptive drawings, attempting to feel the values of each. If you can succeed in doing this, then you are already well on the way to learning how to become what you are – an artist.

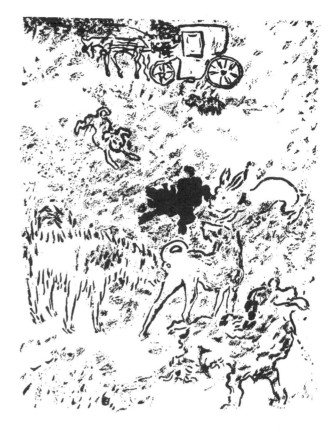

16 Edward Ingram Taylor (1855-
1923) *Marsh Mallow* pencil.
Victoria and Albert Museum

17 Pierre Bonnard (1867-1947) *Seven
Dogs* lithograph from *L'Escarmouche*, 1893

18 Harold Gilman (1878-1919) *The Factories, Leeds* pen and ink. Victoria and Albert
Museum

In my bamboos I am really only setting
forth the untrammelled feelings in my
breast; how then could anyone ascertain
later whether the painting shows a
formal likeness or not, whether the
leaves were close together or sparse, the
stems slanting or straight? Often, after
I have been spattering around for some
time, other people look at it and take
it for straw or rushes, and I myself
can scarcely tell any better whether it
really represents bamboos.

CHANG YEN-YUAN
Ninth century, quoted by R. Goepper *The Essence of Chinese Painting*
Lund Humphries Ltd

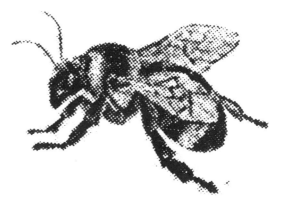

19 Thomas Bewick (1753-1828) vignette from *Aesop's Fables*, 1818, wood engraving

Materials and technique

Drawing is fundamentally really a matter of making marks on a surface, and of course there is a multitude of ways in which one can do this, ranging from the conventional use of pencil on paper to the more exotic methods of sgraffito, cigarette burning, or etching with acids through plastics and metals. One might use an unconventional medium, as Chatelain did, given as he was to producing admirable little drawings with a quid of chewing tobacco taken from his mouth; or one may change the working surface, as Augustus John once did when he dashed off a portrait for his friend Arthur Symons on the surface of a table cloth (now preserved in the British Museum). One may work small or large: small, perhaps drawing in minute detail a picture of a bee to its natural size as Thomas Bewick did for a vignette to Aesop's fables (plate 19); or large, perhaps being ambitious enough to work for over 200 hours on one single drawing as the illustrator John Lord once did (plate 20). One may be ordinary or extraordinary in one's work: perhaps the most extraordinary drawing of recent times was that begun in 1966 by a group of artists and which stretched continuously from London to Amsterdam. This remarkable

20 John Lord (b.1939) *Beneath the Tree* 1966, pcn and ink

drawing was planned by Tjebe van Tijen, and was begun in August outside Carlton House Terrace, London, and as a continuous line crossed pavements, went vertically up walls, over taxis, by cab to London airport, the line being extended meanwhile inside the cab and over the driver himself, and in a similar spirit by air to Schiphol Airport, across the tarmac and then by bus to Amsterdam, through the streets to disappear into a gutter outside the Stedelijk Museum!

Drawing evades precise definition because of this variety of treatment to which it is heir. The best that one can say is that drawing is a matter of making marks on surfaces.

Anyone who wishes to learn how to draw must be prepared to extend his knowledge as to how such marks may be made, and so in this chapter we shall take a look at materials and methods – examining first the conventional groups, which involve things like pencils, pens and brushwork, and then examining the more unconventional methods, which involve such delights as wax scratching and glue drawing.

All drawing is done with line, whether it be a delicate metalpoint line of the kind used by Pisanello for his drawing of a dromedary (plate 22), or whether it be a broad slash of chalk or pastel, like the single stroke behind the right shoulder of Tonks' army officer (plate 21). All drawing is done with line, and so it is not out of place for us to think about the nature of line. *A line is an idea given form.* In order to create a form, however simple, an artist must expend energy. The nature and quality of his line is determined by the quality of the energy expended by the artist. This is why every line which an artist produces is so individual; for it is indeed an expression of his own inner being. As the artist works honestly, and as he comes to terms with himself (which is the real business of art), his line becomes more and more individual, until it finally is the perfect expression of himself. This is one aspect of the line, the 'personality' aspect, as we might call it.

Another thing to remember about line is that it is not a product of nature, but a product of art. One does not see the world bounded by lines – one sees, among other things, the meeting, merging and clashing of tones, which may very easily be seen as lines, but except in a few details of nature – such as the veins of leaves – and in man-made things, the line scarcely exists in the world. This fact has sometimes worried artists, at least, those artists who have felt that it is the duty of art to reflect the outer world; so they have recognized a conflict between drawing, in which one employs lines, and nature, which does not employ lines. But we are concerned with drawing, not with nature, and one draws with lines. In any case, it is a sign of how far man has become alienated from nature that he has come to think of something which he produces, such as a drawing, as something other than a product of nature! Blake maintained that *because* there are no lines in nature, then for that reason alone the artist should be all the more insistent in using line, since art springs not from nature, but from the imagination: 'nature has no line, but imagination has' are his much-quoted words. Ingres was also a great believer in line, and he knew how to use it most sensitively, being one of the first artists to use the carbon pencil which is quite distinctly an instrument for line drawing; as for this question of there being no line in nature Ingres made his opinion very clear, 'smoke itself should be expressed by line!' he maintained.

Of course, the word 'line' covers a multitude of things, as a brief examina-

21 Detail from plate 12
Study of an Army Officer

22 Copy of Antonio Pisanello's
(1395-1455) *A Dromedary* pen
and brown ink. British
Museum

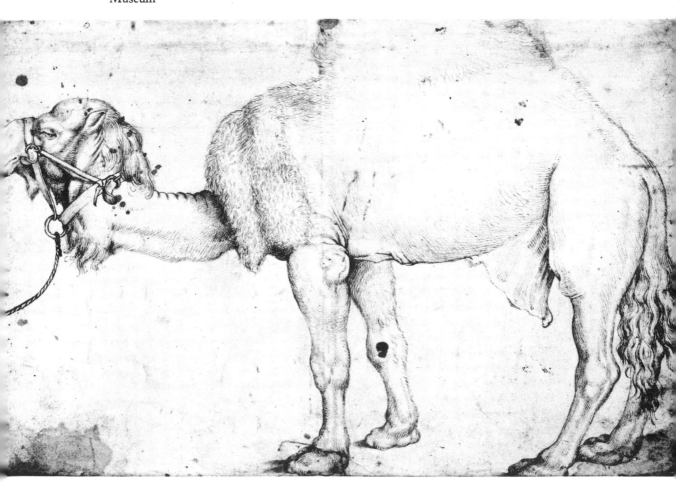

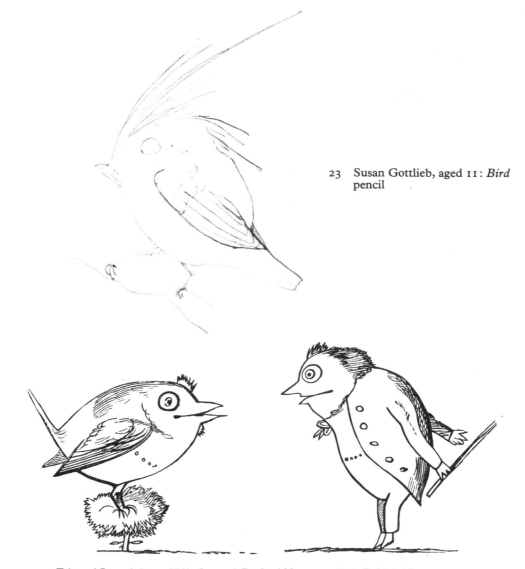

23 Susan Gottlieb, aged 11: *Bird*
pencil

24 Edward Lear (1812-1888), from *A Book of Nonsense* 1846. British Museum

tion of the pictures reproduced so far will confirm. Look for example at the abstract drawing in plate 9. It demonstrates something of the variety of line which is available even within the framework of one technique – that of pen and ink. The drawing contains a rich variety of lines, from the sensitive scratch to rich slabs of ink feathering. The moral of the drawing is that with such a wide variety of line potential, one has to ensure that one selects the right kind of line to convey particular feelings in a certain drawing. Perhaps one of the most useful exercises upon which you could embark at this moment would be to make a similar abstract drawing in pencil or ink in order to study the line potential of a drawing material. There need be no thought for 'beauty' of content in your experiment – indeed, it might even help you if you try to make your drawing as ugly as possible. Try to catch the different feelings which certain lines exude: you must become sensitive to this 'quality' of a line. A drawing of a bird in a sensitive searching pencil line will

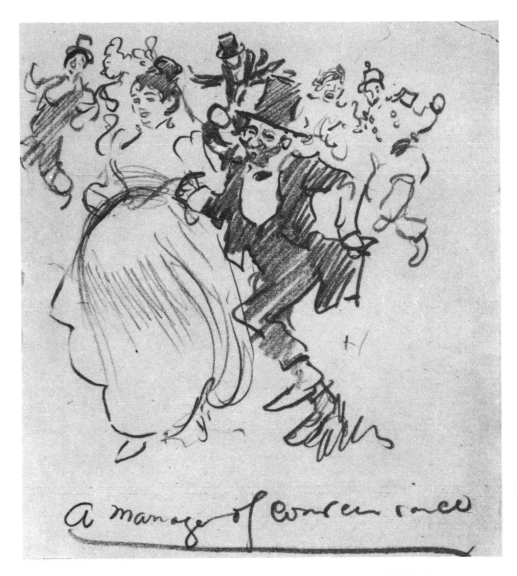

25 Phil May (1864–1903) *A Marriage of Convenience* c.1890, pencil. British Museum

be quite different from a drawing of the same bird in a heavy slab line. Compare the birds in plates 23 and 24, for instance, if you want to see what I mean: the delicate pencil lines of the child's bird would be quite out of place in the humorous context of Lear's own limerick illustration, for which he quite sensibly chooses a rich vital pen line, which pulsates a coarse life of its own.* As a further example examine the drawing *A Marriage of Convenience* by Phil May (plate 25) and see how the urgent strokes of pen and pencil convey an energetic fervour necessary to the subject. Almost any other kind of line would have been inappropriate for the drawing.

* I think it only fair to point out that Lear could draw a very sensitive line when it suited his purpose – his topographical drawings are justly famous, and his lithographs for at least one book (*Tortoises, Terrapins and Turtles* by J. E. Gray, 1872) are among the most sensitive book illustrations of the Victorian era.

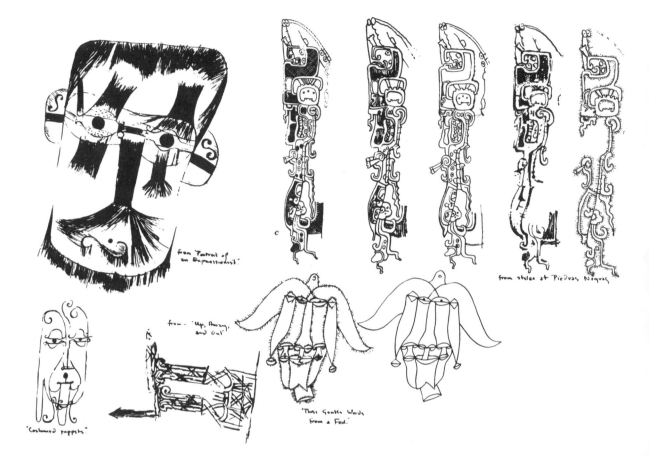

Within the illustration:
from 'Portrait of an Expressionist'

from stelae at Piedras Negras

from 'Up, Away, and Out'

'These Gentle Words from a Fool.'

'Costumed puppets'

26 Fred Gettings, page from sketchbook – experiments with Klee, 1967. Private collection

A line, then, is an idea given energy. This is implicit in conjuration, in which a magician augments the magic of his words by drawing sigils and magic signs around him, giving an outer form to his inner energy, which is magic. Each time one draws a line one is practising a sort of magic, and perhaps this is why the word which the Aztecs use for artist means 'he who makes alive'. The power of the line, the power which can invest an idea with form, is openly involved with magic, and the artist, when he works, is a magician. Paul Klee knew a great deal about this form of magic, about the nature of line, and in some way almost all of his graphic work is the result of consciously making alive, of 'taking a line for a walk' which is his phrase, a fair summary of the drawing process. Taking a line for a walk suggests the idea of keeping an energy on a leash, an energy with an almost canine need to pull against the artist, to sniff at obstacles, anxious to be free. Real drawing is very much reflected by Klee's image, for the pen does tend to run away with one; the

hand draws, and one may watch it drawing with a sort of detached amusement. In cases like these there is a direct communication between the energies of the subconscious and the hand itself. The energy, the tug of the animal, manifests itself in a particular quality or feeling of line.

The purpose of the next exercise is to examine the wide range of lines which offer themselves always as a potential to the artist, and to confound forever the prejudice that drawing is merely a matter of bounding an object with a single line, much like a wire frame. The drawings in my sketchbook (plate 26) were done to 'feel' the quality of the lines which Klee had used as I copied his work, to find out in what mood Klee had taken each of his lines 'out for a walk', in the hope that this would teach me something about line itself. My aim was to analyze the linear quality of the four details I had chosen, and then to draw a few abstract figures each in a linear style reminiscent of one of the Klee drawings I had analyzed.

In the large face, which is a detail from *Portrait of an Expressionist*, we find a graphic structure which is based on contrasts – a simple contrast between straight lines and curves – the straight lines of the nose, the structures above and below the eye orbs, the straight lines in the ears against the curves of the head, ears, eyes, chin, and so on. This graphic contrast was an intentional device to convey the inner turbulence of the face – an emotion suitable for an expressionist. It is hardly surprising that this contrast of lines is also echoed in the treatment of the lines themselves: a remarkable variety of lines and textures has been used, to contribute to the feeling of a lack of ease. Compare this variety of linear treatment with any of the remaining three drawings: the lines in some cases are open and sensitive, in other cases they are so herded together as to appear like black solids, or coarse wire brushes. In places the line is very delicate (the hair-line shading around the ears, for example), while in other places the treatment is very harsh: this of course heightens the sense of contrast.

I made a study of three other Klee drawings, and then attempted to transfer the distinctive line treatment to four abstract drawings based on the form of an Aztec dragon. I drew the first one in the style of the *Expressionist* – pressing my thumb and fingers down on to the wet ink in order to give extra textures where I considered necessary. The second drawing was in the style of *Costumed Puppets*, which is to say in a fluid, gently varied line. The third drawing followed the exuberant richness of varied pressures and textures which we find in the detail from *Up, Away and Out*, while the fourth consisted of an attempt in the curiously haired style of the *Fool*.

Each of these four drawings exudes a feeling of its own, and unlike the drawings by Klee, which are of different subjects, drawn in a variety of ways, these are all different mainly because of the treatment of the line: there is a delicacy about the second, a robust energy in the third, and a plant-like quality in the fourth, and these 'qualities' spring solely from the nature of the line employed.

Find four drawings (not necessarily by the same artist) which exhibit considerable difference in the treatment of line, and then make an 'analytic copy' similar to mine of the Klee drawings. Then study the line by producing a series of drawings in the linear techniques similar to those you have copied. Use only one medium for the exercise, and do not follow either the drawings or the line treatments too slavishly – it is more important that you should

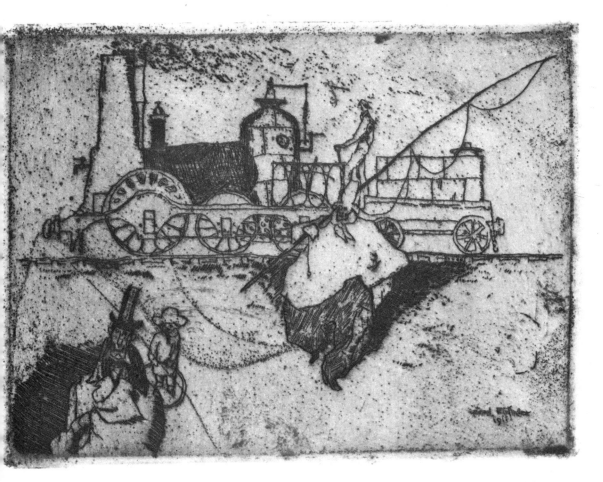

27 Lyonel Feininger (1871-1956) *Die Kleine Lokomotive* 1911, etching. British Museum

catch the feeling of the lines than that you should produce perfect copies.

Now look at the ways in which lines may be used in combination in order to produce textured effects or to suggest tone. Lyonel Feininger's delightful etching (plate 27) may be used as an example of the use of texture and tone. In the very left corner (plate 28a) there is a dark area of shadow drawing in what is called parallel hatching; this is a strong and powerful method of presenting tone, and the strength of the surface it presents depends very much on the vigour of handling. This point may be taken if you examine the softer parallel hatching in the charcoal drawing by Lely in plate 103, for almost all the tone of this drawing has been conveyed in this manner. In the pantaloons of the central figure of this etching (plate 28b) a lively area of tone has been conveyed by the use of a kind of patchwork of short parallel hatchings, each little patch of lines moving in a direction contrary to the one next to it. An excellent, but perhaps more fluid, example of this patchwork hatching may be seen in the nude by Margo Kell (plate 49). Behind the clown-like figure

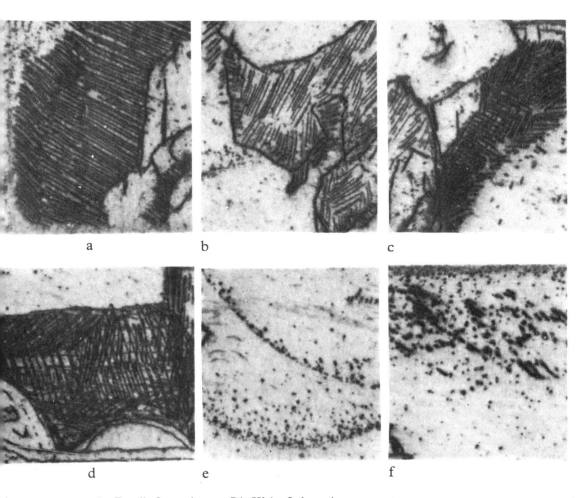

a b c

d e f

28 Details from plate 27 *Die Kleine Lokomotive*

(plate 28c) a much darker area of shading consists of parallel lines crossing each other; this is, of course, known as cross-hatching, and is perhaps the most famous of all linear methods for suggesting tone. The working of Emilio Greco's nude in plate 101 is a good example of rich cross-hatching, and reminds us that cross-hatching may be orderly (perhaps 'mechanical' is a better term) or it may be disorderly, or 'lively' as in the area of tone on the boiler of the locomotive itself (plate 28d). The mechanical cross-hatching allows a fairly even distribution of white paper to show through shading, while the disorderly cross-hatching allows broken and uneven areas of white to show through. Both of these forms of hatching are of course suited to different purposes. The remaining areas of tone in the etching are conveyed mainly with the use of dots, or tiny strokes – the dots are evident in the foreground (plate 28e), the rich textures of white tiny strokes which are almost dots themselves may be seen most clearly in the smoke (plate 28f) which issues from this strange engine.

29 Caroline Tipple (b.1948) abstract drawing, 1969, pen and ink
30 Photograph of a paving stone, taken by the author

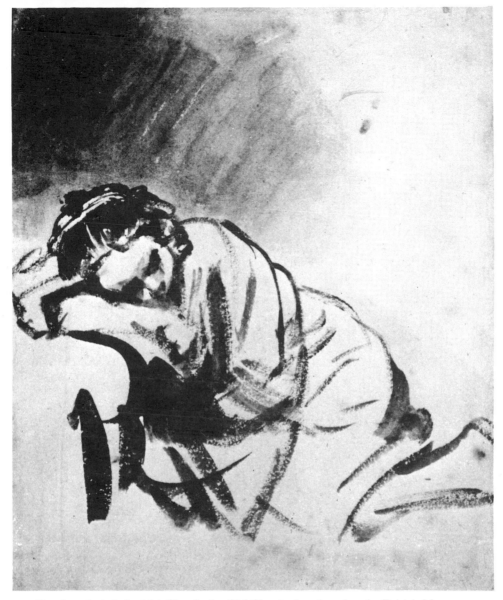

31 Rembrandt (1606-1669) *Sketch of a Girl Sleeping* brush and sepia. British Museum

The next exercise is to produce a drawing which incorporates these six different methods of conveying tone. The example – plate 29 – was one of a series produced by students based on my own photographs of paving stones. I reproduce a photograph of similar paving stones in case you would like to use it as the basis for this abstract study of graphic techniques.

A related experiment in line is to make several versions of the same drawing – perhaps indeed that of a paving stone – in a variety of different media; use a pencil, pen, biro, brush, chalks, crayons, and so on for each of your drawings. Certain methods of shading, of making a tone, suit certain materials better than others. You can do things with a pen, for instance, which you cannot do with a brush (try cross-hatching with a brush, and you'll see what I mean), and certain techniques cannot be separated from certain ways of seeing – one cannot separate Rembrandt's drawing of a sleeping girl (plate 31) from the idea of brushwork – here indeed is a calligraphic equivalent of life, if ever there was one!

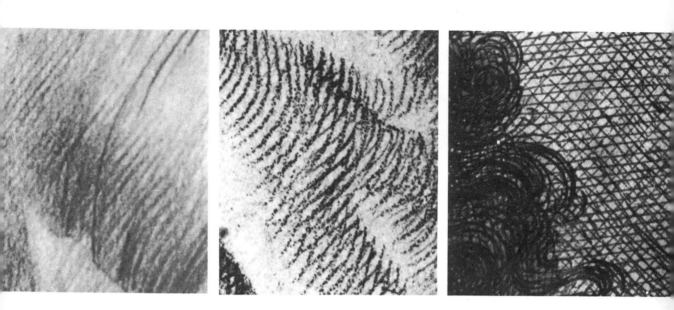

32

33

34

32 Detail from plate 39, pencil

33 Detail from plate 47, chalk

34 Detail from plate 50, pen and ink

The method of achieving a certain graphic effect, such as an area of tone, should spring from the nature of the material actually used. In plates 32 to 37, are reproduced six details in different media from pictures used in this book – each detail is almost a tiny 'abstract' picture, depending for its form on a combination of handling and media; if you look at these details, and attempt to relate them to their sources you may see something about how all competent drawing is at root a question of dealing with abstract qualities.

Even slight variations in handling can give rise to very different graphic effects. If, for example, you hold a pencil upright and apply an even pressure, you will obtain an even line which sensitively records the various slight variations in muscular tensions as your hand moves. If you hold the same pencil at an acute angle to the paper, then you will find that you are drawing with a much wider area of carbon to the paper, and consequently the variations in thickness are more pronounced, and depend not only on muscular tensions, but also on the surface of the paper. Not only the angle of the pencil, the varying pressures of the hand, and the texture of the paper determine the quality of line, however; the nature of the carbon itself also affects the nature of the recorded mark. A hard 'lead' will give a lower scale of contrasts, while a soft 'lead' will give a high degree of contrast. All such considerations as these affect our drawing, and we should aim to become familiar with a wide range of drawing tools and to become aware of the graphic potentialities of each one, so that when we have the urge to make a drawing in a particular way,

35 36 37

35 Detail from plate 54, wax sgraffito

36 Detail from plate 56, monoprint

37 Detail from plate 81, brush, ink and litho chalk

to express a particular thought or emotion, then we shall know precisely which instrument would suit our purposes best. There is little point in theorizing about the nature of graphic materials – the only useful way to find out about them is by experimenting with as wide a range as possible. However, the following general notes may be useful for the beginner who wishes to experiment in order to master the tools of his trade.

The most usual of drawing surfaces is, of course, paper – an ordinary material with a most extraordinary history: invented by the Chinese, introduced to Europe by the Arabs, who learned the secret of its making from Chinese prisoners of war, and with a name derived from an Egyptian reed*. Paper itself consists of a surface of interwoven fibres, which may be of a vegetable, mineral, animal or synthetic material, prepared by being beaten and cut down to a fibrous pulp and pressed flat to dry on wire screens. The surface of this pressed fibrous film may be prepared in various different ways, depending on the purpose for which the paper is intended.

*The invention of paper was first announced by T'sai Lun in 105 A.D. The manufacture of paper was introduced to Europe (Spain) sometime in the eleventh century by the Arabs. The oldest piece of European paper in England is a letter (c. 1216) to Henry III of England. The word paper is, of course, derived from papyrus, the reed which was used almost universally in the ancient world for the manufacture of pliable writing surfaces. One of the many curious things about the history of paper making is the fact that both the Aztecs and the Maoris knew how to make it before western culture reached them!

So far as the artist is concerned, getting to know papers is really a matter of getting to know the surface textures of papers, and noting how they receive inks or pencil marks. One artist may prefer a rich texture (grain, or tooth, is the technical term) to work on, while another artist may prefer a smooth surface. Most good drawing papers are made from the strongest of rag fibres, and are hard-sized with a coating of gelatine to give a receptive working surface. Unsized paper is called waterleaf, and, being much like blotting paper in quality, it is difficult to draw on – yet even so, it is favoured by some artists. Many different paper surfaces are produced by what is called 'loading', that is by brushing on a coating of china clay and other chemicals in order to lend a texture, weight and opacity to the paper. These loaded surfaces are often highly polished (by a process known as calendering) – and the result is that when a hard sharp pencil is used on certain of these papers, not only a carbon line is left behind, but also a furrow is bitten into the clay surface – yet even so, some artists favour calendered loaded paper for their working.

It is quite beyond the scope of this book to describe the available makes of exciting drawing papers; all kinds of weights, textures, strengths, thicknesses and colours are available, at all kinds of price, and although one might generalize by saying that for pencil work an expensive cartridge goes well, for general pen work, a hot-pressed illustration board, and for chalk or pastel work a tinted paper with a rough surface it is in fact impossible to generalize. One might, for instance, condemn a certain pulp paper because it gives a blotchy appearance when a charged pen is used on it (since the fibres of the paper conduct the ink like papillary ducts), yet an artist might well find that precisely this effect is required for a drawing which he is doing. The best advice one can give a beginner is that at the very outset he should invest a few shillings in buying twenty or thirty different qualities of paper and that he should experiment on these in a variety of media.

Artists tend to talk about effects of pen, pencil or brush and so on without much thought of the surface to which they are being applied. If you try the experiment of working with the identical pen and ink on a series of different paper surfaces, you will see how ridiculous this is. In some ways the effects of line depend more on the nature of the paper than on the quality of the drawing tool. A smooth, super-calendered paper, more popularly known as an 'art paper', will allow a pen to glide over its surface, while a paper with a rough quality surface, will 'pull' against the sharp nib of the pen and cause it to 'drag', producing an interesting burr on the edge of the line. Similarly a hard, rough paper will 'rasp' at the soft pencil 'lead', in the manner of a file, and leave the texture which a smooth paper would not provide.

Even inferior drawing papers do not generally have the watermarks which are found on all writing papers. The so-called watermarks are really 'drying marks' – intentionally constructed designs left on the surface of the paper by the manufacturer who inserts a wire design on the wire frame upon which the paper dries. These trade marks are not found on drawing paper because the slight indentation of the paper surface would interfere with the drawing itself. Some good quality hand-made papers do have watermarks for identification and for authentication purposes, but these are placed in a corner or on the very edge of the sheet. The wire bed upon which the paper dries is rather like a sieve; the wires may be parallel (giving the so-called 'laid' papers) or they may be woven as a mesh, but the result in either case is that there is a

mechanical texture on the back of the paper itself. Naturally, the correct side of the paper for drawing is the one with an uneven tooth, for the mechanical screen of the paper back looks very unpleasant when it shows through a drawing – especially this is so when a continuous pencil shading is used. You can find the 'mechanical texture' side by holding the paper up to the light, and bending one corner over into a loop – the light will show the mechanical surface quite clearly.

Certain boards have been made expressly for pen work, and although these tend to be expensive, they are excellent for almost any graphic medium. Illustration board is ordinary drawing paper, hard-sized to enable the ink to float on the surface rather than be absorbed into the paper, mounted on to hard, firm card. Bristol board, so named because it was originally made in that city, was a high quality pasted card, with up to twenty rag-paper sheets pasted together, but the name is now applied to boards with an inferior quality sandwiching, with good quality papers on the surface.

Tracing paper is really ordinary paper which has been prepared in the usual way but which is brought to transparency by being treated with a mixture of resins, gums and oils. The manufacture method means that it is very hydrated; it therefore tends to pick up moisture from the air, and must be stored in waxed wrapping or in a sealed tube, for otherwise it will cockle. For the same reason, it is not possible to work with washes of ink or water on to tracing paper. Half tones can be rendered with lithographic chalk, with splatter work or with mechanical tints, such as Zippatone or Letraset texture. A good quality tracing paper (that is one with a good bluish tinge, smooth surface, and one which crackles when it is handled) is excellent for pen work, especially as it is possible to scratch out unwanted lines easily, and even to scratch white lines into solid areas in order to render special textures. The various acetate tracing sheets on the market are also useful in this connexion, Kodatrace being by far the best.

The most popular of modern drawing inks is also the oldest. Indian ink, which is a misnomer for ink of Chinese invention, has been used for over five thousand years: it is the most permanent of inks, manufactured from a mixture of lamp-black carbon and gum. Some Chinese inks are so durable that fragments of Chinese text which have lain under water long enough for the paper blocks to mineralize, still contain perfectly legible ink texts!

Some other inks have an iron-gall content, and it is one of the chemical properties of the basic ingredients which has actually given us the name *ink**, since the acid content of the liquid actually eats into the paper, a fact which gave rise to the name *encausticum*, the purple ink used by Roman emperors. Bistre is an ink with an iron content, but unlike the majority of these inks its colour does not change through oxidization, and its main virtue is that it does not loose its original brown fluidity. Sepia ink, which is made from the pigment of the cuttlefish, is dark and cooler than bistre and has a much wider tonal range, as anyone who examines the sepia drawings of Samuel Palmer will see. The most practical note to make when buying ink is whether or not it is waterproof when dry. Since it is usually a shellac and borax additive which makes the ink 'waterproof' it is quite possible to dilute the ink with

*The Greek word καιω 'I burn' – hence *caustic*, then *encausticum*, which gave rise to our word ink.

38 Josef Herman (b.1911) *Study from the Nude* 1953, pen and wash. Victoria and Albert Museum

water to make a wash (plate 38) either while it is drying on the paper, or before use. Some inks tend to 'scum' in a rather unpleasant way, however, when mixed with water.

Until well into the nineteenth century the most common form of drawing and writing instrument was the quill pen, which was made from the feathers of swan, goose or turkey – though it was more usual for the crow quill to be used for drawing. Pens made from reed stems were more popular in the ancient world, but it is from the Italian word *penna*, which meant feather, that our own word is derived. With the invention of the metal pen, the style of drawing was changed considerably; the old connexion between pen drawing and calligraphy, which sprang mainly from the dual purpose of the pen, tended to disappear – the metal tip allowed a more flexible, thinner line, yet

at the same time it tended to lose the rich decorative feeling which the quill and reed pen had allowed. It is not accident that an artist like Vincent van Gogh, who was so much a *decorative* painter, should revert to the use of a reed pen in his ink drawings. Nowadays it is possible to buy a wide range of nibs which between them will allow almost any thickness and quality of line. It is a good practice to buy a few wooden pen holders and a fairly wide selection of drawing nibs which may be inserted as required. Biro pens, named after their Hungarian inventor, exhibit none of the elasticity or virtuosity of handling which one may obtain with the steel pen; indeed, the fact that the ball tip is running a layer of a specially viscous ink on to the paper means that a very small variety of line thickness is possible. Its chief advantage is that it does not require constant dipping, and it is therefore ideal for long stretches of quick sketching and note-taking, where the quality and expressiveness of the line is not important. The chief disadvantage is that under the warmth of the hand, or the body, the pen tends to burst and the ink flows free – this is why the biro (and all such capillary action pens) is forbidden in almost all museums and public print collections. I frequently make use of the biro for sketching, and find the most satisfactory results are obtained on a hard, highly textured paper.

The pen, unlike a soft pencil, charcoal or brush, is really an instrument for close working, and depends for its accuracy of handling and flexibility on a tight control over the movements of the hand only. This is also true for hard pencils, and indeed any technique in which delicate working is required. For boldness of execution, where an entire wrist action, or even a whole arm movement, enters into the formation of the strokes, the soft materials of brush and ink, charcoal, conté crayon, lithographic chalk, felt tips and so on are much more useful. The Japanese Pentel comes somewhere between these two hard and soft drawing techniques, as it consists of an ink-impregnated bamboo in a plastic holder, which gives a delicate line when held upright, and a broad line when held at an angle to the paper. The point wears away quite quickly, however, though it is especially receptive to the minute flexions in pressure, and since the ink itself is not jet black, there is a great potential for a variety of tones.

The pencil is a surprisingly modern invention, for it did not find the form with which we are familiar until the end of the eighteenth century, when Conté perfected a method of mixing clay and graphite to give different degrees of hardness. It was not until the nineteenth century, until Brockendon invented a method of compressing powdered graphite, that the instrument acquired the peculiar softness and delicacy we associate with it today (plate 39). A wide range of carbon pencil is now available, from the extremely hard 9H to the soft black of 7B, though most artists work to a much smaller range, rarely going beyond 2H for delicate work, and rarely choosing a softer 'lead' than 3B.

Many early drawings look as though they might have been done with a sharp pencil, but are in fact done with metalpoints. These are short lengths of metal sharpened to a point and mounted in a holder for ease of handling; there was at one time a variety of these metalpoints available, including silver, gold and lead. The lead point, which was more precisely an alloy of two parts lead to one part tin, was extremely popular, and it is probably the similarity between the carbon line and the dark, metallic sheen which the lead point

39 Sir Stanley Spencer (1891-1959) *Self Portrait* 1927, pencil. Victoria and Albert Museum

leaves which accounts for the persistence of the misnomer 'lead' applied to the modern pencil. These hard point metals required a specially prepared surface to take their lines, and so the drawing paper was prepared with a thin coating of a finely powdered bone which had been burned white, and which was usually mixed with some colouring agent to tint it rose, green or blue. The powder was fixed to the paper surface with a special gum solution, and then smoothed over with a stone or animal bone. When a metal point, such as silver, was applied to such a surface a quantity of the metal would be abrased off by the rough surface to leave a line. In the case of silver being used

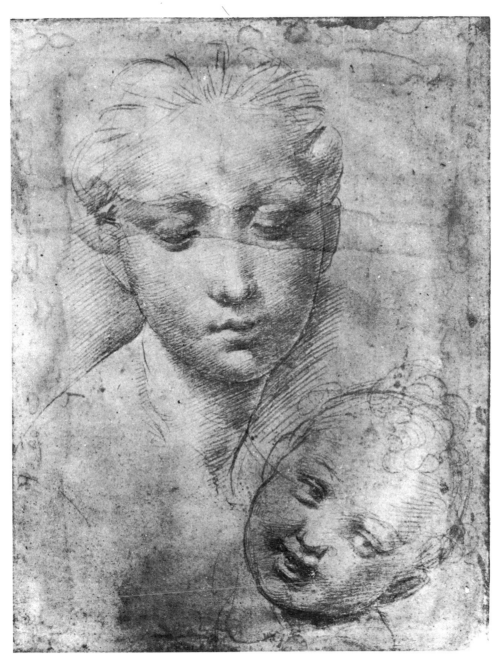

40 Raphael (1483-1520) *Heads of the Virgin and Child* metalpoint on pink prepared paper. British Museum

as the drawing agent, the line would later oxidize to a deep brown, unless it was first protected with a fixative. Metalpoint lines, once made, could not be corrected, yet a very great delicacy of handling was possible, and the technique became especially useful for the realistic portraits which were so much in demand in the fifteenth and sixteenth centuries. It was essentially a technique suited to the demands of realism, as the silverpoint by Raphael in plate 40 suggests, and this probably accounts for the fact that metalpoints are nowadays rarely used in spite of the great linear potential and the great beauty of the metal itself.

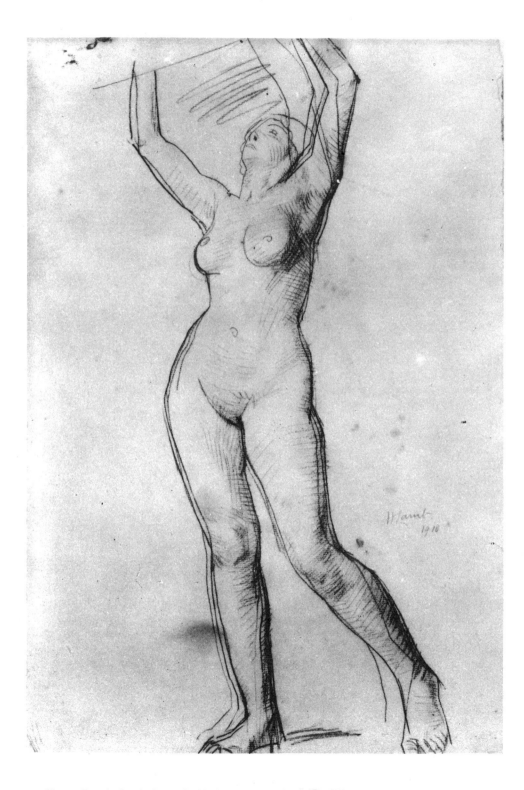

41 Henry Lamb *Study from the Nude 1910*, conté crayon. Victoria and Albert Museum

While touching upon a drawing instrument which gives a line not easily erased, we might actually take a look at rubbing-out materials. The oldest erasing substance, dry bread crumbs, is still in many ways the best, though there are several modern materials, soft rubber erasers and so on, which rival the old methods now. However, I would like to make the point that erasers should not normally be necessary; the truth is that rubbing out reveals an unfortunate attitude of mind to drawing. Erasers should be used for cleaning up a drawing sheet, but not for making actual alterations to the drawing itself. Erasing springs from a wish to 'hide' mistakes rather than to learn from them. As you can see from the multitude of lines which go to make up the contour of Lamb's delightful nude drawing in plate 41, the tendency with great draughtsmen is not to rub out incorrect lines, but rather to use these as guides for more positive and more accurate statements. In this way a series of linear statements gives rise to a plurality of lines which together make a rich statement of a contour. The strange thing is that even when there are many lines on a drawing, as in plate 41, the right one somehow shows through, yet none of the 'wrong' ones are superfluous, and indeed these often add to the vitality of the drawing. An analysis of Lamb's drawing shows how difficult it is to determine precisely which of the actual lines of, say, the right leg, is the definitive statement of the contour of that leg. The nature of such a rich line reminds us that after all there is no line there in reality: the form curves away from our eye, and does not 'end' in a line, so that this sensation of a living, disappearing plane, the curving away from our field of vision, may sometimes be more convincingly suggested by a plurality of lines which suggest a sort of 'haze' of indefinable planes, and which perhaps correspond more precisely to the actual reality.

I admit, however, that correction is sometimes necessary – particularly for work which is going to be reproduced. The best way to correct ink drawings is with the aid of a razor, which is used to scratch off the unwanted lines as gently as possible, with the razor edge held vertical to the card surface; and then smooth over the roughened surface with the back of a wooden spatula. Alternatively, corrections to pen drawings which are intended for reproduction should be made with a special paint known as process white – normal white paint does not adequately conceal the line from the process camera. From rubbing out lines, let us move to the idea of preserving lines. All 'soft' drawings, which are those done in such materials as chalk, pastel, charcoal, and so on, are liable to smudge, and may therefore be fixed by laying a coating of shellac over the surface of the drawing. Art shops stock several kinds of useful fixatives, some of them in aerosols, but I would not recommend their indiscriminate use. When a coat of fixative is sprayed on to a soft drawing a great deal of the crispness and vitality of that drawing is usually lost – the paper surface is 'deadened', and the consequence is that one often removes the important quality of the drawing which one was so anxious to preserve.

At this stage it will be sensible to examine one or two drawings by master draughtsmen to see something of how techniques and materials combine when used conventionally, and with the underlying idea that, in an attempt to learn something of how a master works, you might try one or two drawings with the materials we examine.

If you compare Terry Frost's drawing of dockyard gates (plate 42) with

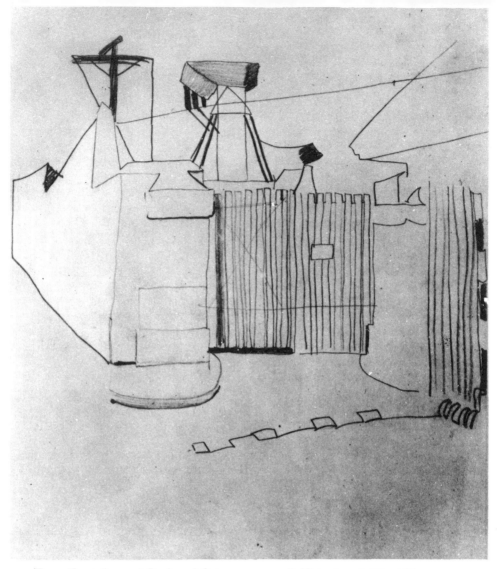

42 Terry Frost (b.1915) *Dockyard Gates* 1951, pencil. Victoria and Albert Museum

Palmer's drawing of tree trunks (plate 43), you will see something of the difference between an organic line and a considered line. Although the pencil lines of Frost's drawing are flexible and of a variety of thicknesses due to the variations in hand pressure, they are lines which have sprung from a wish to set down rapidly a particular set of forms; the nature of the line is subjugated entirely to these forms and takes its structure from the unconscious handling of the pencil. Although it is a sophisticated used of line, Frost has not put a great deal of attention into its quality, but has allowed its nature to evolve directly from the handling of the pencil. This is what we might call an *organic* line. The lines in Palmer's drawing of trees are of quite a different order, for each one has been carefully considered, carefully worked into, so that the drawing might even be used to exemplify a wide variety of line structures. You can with ease count about ten different qualities of line, and indeed each tree has been ascribed its own particular 'feeling' of line, and so far as the actual structure of these trees is concerned we may be sure that Palmer paid more attention to the quality of the lines than to the actual forms which they

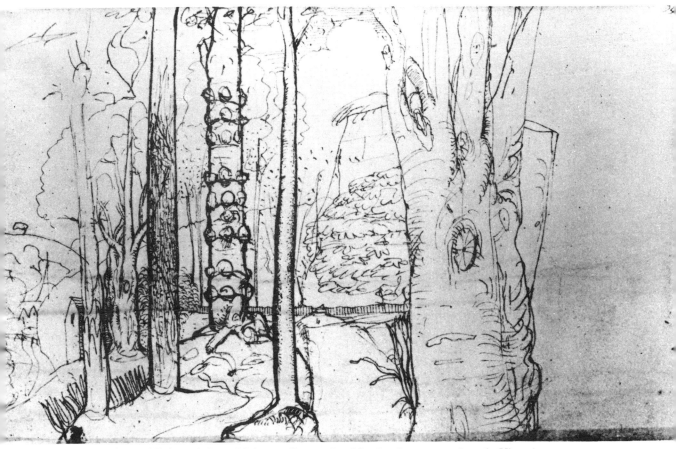

43 Samuel Palmer (1805-1881) page from a sketchbook, 1824, pen and wash. Victoria and Albert Museum

demarcate. This kind of line treatment may be described as *considered*.

Try making two drawings, perhaps even of the same subject, but in one allowing the line to evolve from the actual manipulation of the pen in search of form, and in the other drawing putting as much effort into constructing the quality of the line, consciously attempting to place the nature of the line above consideration of the form which it contains. You will no doubt find with this particular experiment something about the difference between sketching and drawing. A sketch is usually done quickly and with little regard for the quality of the line itself, while a drawing is produced with as much consideration for the nature, quality and beauty of the line as for the subject under treatment.

There can be no doubt that the lovely charcoal drawing by Peter de Wint (plate 14) falls into the category of the sketch – there is a directness of handling, almost an organic quality in the lines, which conveys the quickness of handling in such a way that we may almost count the number of rapid strokes which de Wint made. Notice how he used parallel shading; a technique

44 John Piper (b.1903) illustration from Wordsworth's *A Guide Through the District of the Lakes* 1951 edition, published by Rupert Hart-Davis. Mixed media

which comes easily to the soft, blunt and feathery charcoal line. A quite different approach to landscape may be seen in Cameron's structural ink and wash drawing of a valley (plate 46): here the delicacy of line and the fact that he left so much of his paper white has helped to contribute something of the feeling of space which is so essential to good landscape drawing. While we may generalize wildly to the extent of saying that the graphic problem inherent in life drawing is that of coming to terms with form, we may generalize just as wildly by saying that the central problem of landscape drawing is that of expressing light and space. The great masters, for example Rembrandt or de Wint, could with just a few well-chosen lines convey vast prospects, endless panoramic views which are saturated in an aqueous light. Perhaps you could tackle a landscape and attempt to rival the masters, with light and space as your problem. On the other hand, you may prefer to capture something of the organic quality of a *particular* landscape as John Piper did with his lively illustration of Styebarrow Crag in plate 44. Before you settle down to sketch or draw, make sure that you know what it is that you want to convey or study – is it the atmosphere, is it the light, or is it the peculiar structural form of the place? Be wary of attempting to put too much into a picture, for this will kill it: remember Max Liebermann's definition of drawing as 'the art of omission'.

When we turn to an 'interior' drawing, perhaps to the little gem by Sickert, *Mr Gilman Speaks* (plate 45), we may see something of how a master draughtsman will express a quality of light, atmosphere and depth in one drawing by means of a combination of textures and a loose handling of line. Giacometti was particularly adept at expressing such qualities in his interior portrait studies by blurring the quality of his lines with an India rubber – a technique which I would think springs from a feeling that a line is just *too* definitive to express a feeling of life, depth and atmosphere. Sickert attempts the same kind of 'blurring' effect with the loose handling of his line – there is scarcely one single delineating line in the entire drawing; everything is hinted at, yet each line, each dot, is essential to the whole. Observe the variety of textures he employs, ranging from the dot to the stippling fleck, the horizontal scribble to the bold slash of ink, each single application springing from the nature of the pen itself. As an experiment tackle one of these 'intimist' drawings for yourself, attempting to incorporate into your picture the same fluidity of handling, and something of the same textural range. Remember while you work at all these drawings that your aim is not to make nice drawings, but to study methods and techniques involved with the line.

45 Walter Richard Sickert (1860-1942)
Mr Gilman Speaks 1912, pen and ink.
Victoria and Albert Museum

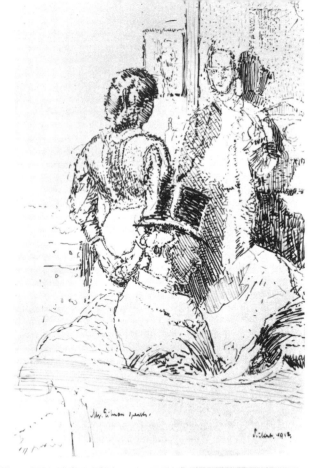

46 Sir David Young Cameron (1865-
1945) *The Valley* black chalk and
Indian ink. Victoria and Albert
Museum

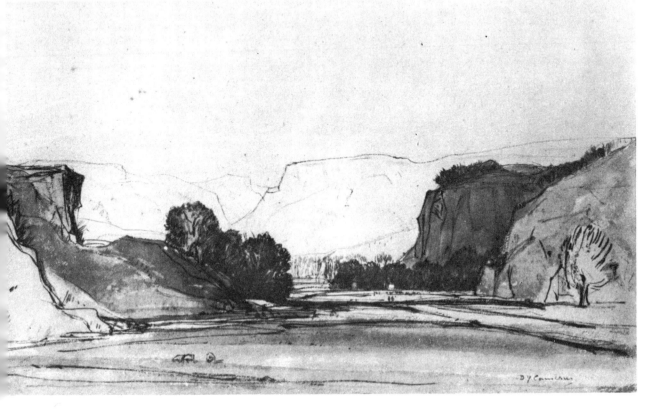

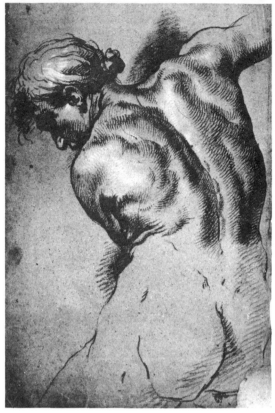

47 Byng (?) (eighteenth century) *Back of a Nude Man* black chalk, touched up with white, on buff paper. British Museum.

48 Alfred Stevens (1818-1875) *Nude* red chalk. British Museum

49 Margo Kell (b.1940) *Recumbent Nude* pen and ink on toned paper. Collection of Mr and Mrs Appignanesi

47

Compare the three drawings by Byng (plate 47), Stevens (plate 48) and Margo Kell (plate 49). Each drawing is of a nude, and each one suggests that the artist has gone to considerable lengths to convey something of the feeling of form. Byng was more interested in the muscular structure of the form, and perhaps Stevens was interested in the general structure of the planes, in how the breasts fit on to the rib cage, and how the flat planes of the arms relate to the underlying muscles, while Kell is decidely interested in the monumental structure of the body. Each of the artists has chosen a graphic technique suited to his own personal aim. Each of Byng's deliberate and controlled short chalk strokes follows the curve of the muscles on the man's back. Stevens' much longer strokes follow the main stress of the form – notice in particular the long lines above the breasts which indicate the plane of the structure around the sternum. Margo Kell's short lines build up a vibrating surface which tends to destroy the form, for the lines conflict in direction, texture and weight, yet this somehow serves to emphasize the linear structure of the drawing, for the shading tends to suggest broad areas of line rather than to indicate form: this is especially noticeable in the handling around the buttocks and down the back of the left thigh. This broad 'line' of shading runs over the top of the hip, up the midriff and along the breasts, then 'under' the arm to the almost faceless head. It is this one fairly solid 'line', being so dramatically contrasted with the grey of the paper, which contributes to the feeling of monumentality in the whole drawing: the eye is presented with simple massing of forms, and is therefore able quickly to grasp the whole. The nature of this quiltwork shading actually produces a sense of motion and life which enhances the drawing in a very powerful way.

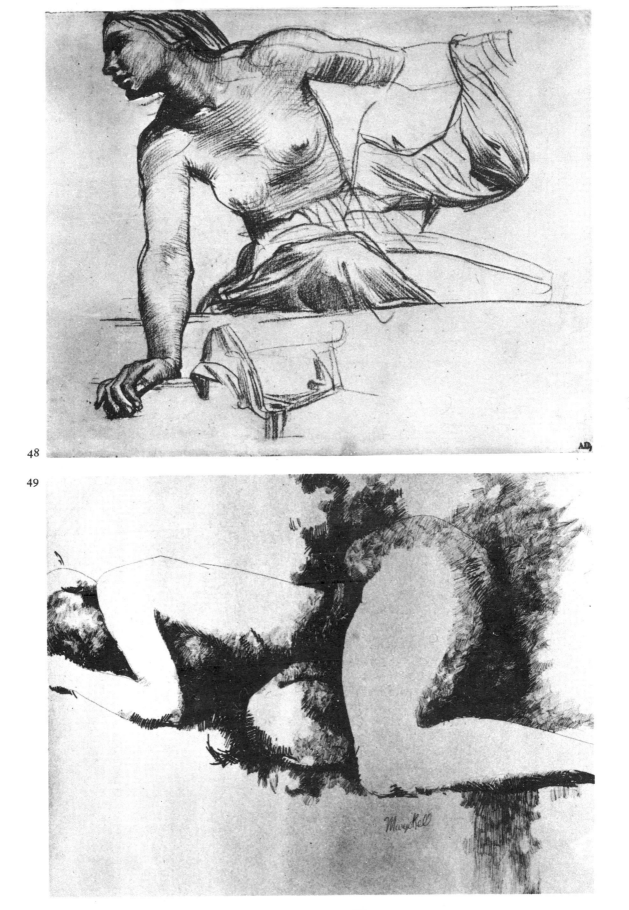

48

49

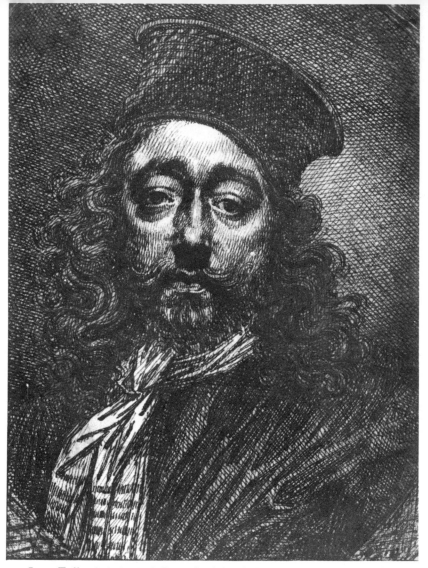

50 Isaac Fuller (1606-1672) *Portrait of the Artist* pen and ink. Victoria and Albert Museum

While we are on this subject of the handling of line we might look at two quite different portrait drawings to learn something about the nature of line. If you compare the portraits in plates 50 and 51 you will see two distinctively different drawings which are different mainly because of the conscious handling. That by Isaac Fuller is built out of numerous carefully applied short lines which follow the form (rather in the way that Byng's chalk lines followed the form, only more closely, more minutely) and have the effect of reducing the whole face to a series of facets and planes in a very interesting manner. The drawing is heavy, solid and corpulent. Powys Evans' portrait of Masefield relies on a more casual handling, but a no less determined technique, for the vertical shading of the parallel lines not only suggests the light and shade around the face, but also describes the forms, and conveys a feeling of seriousness and dignity. Both these line treatments are fairly uncommon, and it may be a good thing for you to try a drawing, perhaps even a portrait, with the idea of rendering what you see in terms of one of these line techniques. Use the one which interests you personally, however – the aim is not

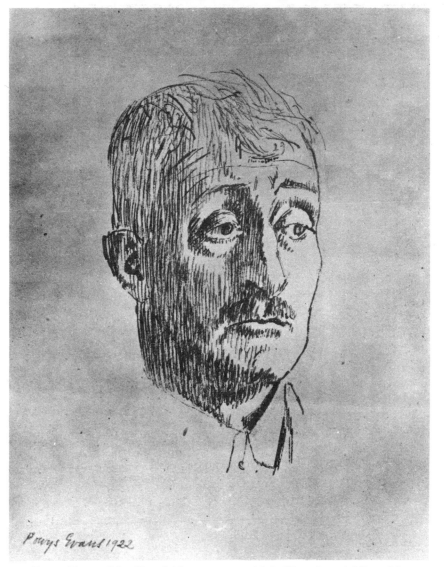

51　Powys Evans *John Masefield* 1922, pen and ink. Victoria and Albert Museum

to graft on to yourself a technique or method of handling which is foreign to you or distasteful to you, but rather to show you something of the range of style available, the study of which will extend your graphic horizons.

We have examined enough 'conventional' drawing techniques for the moment, and so we may now have a look at the more unconventional methods.

Since drawing is a matter of making lines with some instrument on a surface, experimental work may be conducted with changes in either of these two elements. In practice, however, the greatest range of 'unconventional' work is done by changing the nature of the drawing surface rather than the instrument, and so we shall deal with this first. I shall not spend any time writing about the various different qualities and kinds of specially prepared surfaces which may be used; nor about the kind of effects which may be obtained by drawing on music-notation paper as Steinberg so often did, or of drawing and painting on ordinary newspaper as Paul Klee or Franz Kline did, but I shall discuss the various experimental techniques involved with the *preparation* of working surfaces.

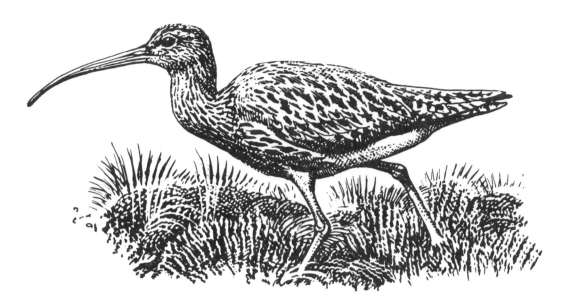

52 Charles Tunnicliffe (b.1901) *The Curlew* from *Our Bird Book* 1947, published by Collins & Sons

Before the invention of paper, artists drew on a wide variety of materials which would nowadays be regarded as highly unconventional, such as skins, silk, wax, clay, grass, wood, bark, leaves, stone, and so on. Any of these materials would be a suitable subject for experimental work. For the moment however, I shall concentrate on drawing surfaces which are suitable for the so-called 'sgraffito' method of incised lines.★

The easiest working sgraffito surface is sold in art shops under the name of scraperboard or scratchboard. This is really a heavy paper coated with a layer of china clay and other materials, upon which one may draw with ink. Any image made on this surface may be scratched or textured with white-line traces, as required. *The Curlew* in plate 52 is a delightful example of Charles Tunnicliffe's scraperboard technique. The shading along the top part of the back of this bird was achieved by first drawing the areas in black ink on the scraperboard and then running a fine point across the black to draw white lines over them in order to reduce their density. Many of the textures on the body of the bird, and on the grass itself, were obtained with different kinds of scraping implements. Most art shops stock a variety of these tools, each consisting of a shaped edge which slots into a holder in the manner of a pen nib; the range of tools permits one to draw lines ranging from a hair thickness up to a thickness of an eighth of an inch. A point of a pair of compasses will be found to work to about the same quality, however.

When scraperboard effects are combined with straight pen work, a remarkable variety of effects may be achieved – cross-hatching in white over cross-hatching in black, for example, will give a particularly rich texture. Gentle variations of pressure with the gouging tool will result in the effects of those lines of grass under the right leg of the curlew in plate 52. Besides using the white scraperboard as a means of adjusting and enriching ordinary pen

★ Almost any method of incising or scratching through a layer of colour to reveal a contrasting underlying colour is now referred to as 'sgraffito', though originally the word applied only to a particular way of scratching through black paint on to a plaster surface.

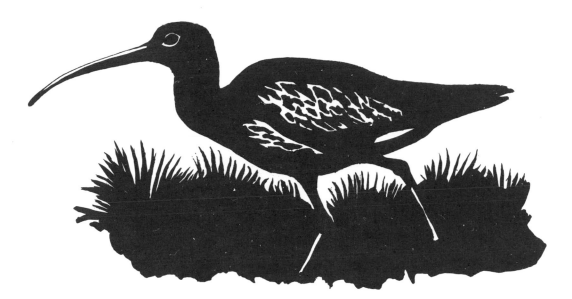

53 Key drawing of *The Curlew* from plate 52

work, it is possible to purchase or make entirely black scraperboards, which are simply the ordinary clay coating covered with a layer of ink. It is my experience, however, that the drawings done in white line on to a black surface serve no real purpose, and are usually just a little harmful since a rather 'slick' effect is easily obtained and this very often passes among the uninitiated as good drawing – the work looks exciting by virtue of its novelty rather than by virtue of its quality. Certainly the best way to regard scraperboard is to think of it as an auxillary to ordinary pen work.

The sensible approach to the scraperboard technique is first of all to work out a design on to a sheet of paper, thinking largely in areas of solid black, with the certain knowledge that you will be able to work into these and adjust the tones later on when you have transferred the drawing to your scraperboard. The key drawing in plate 53 is my own tentative analysis of the original black drawing which Tunnicliffe might well have drawn before working into the drawing with his scraping tools. You should transfer your drawing to the surface of the board with a very soft pencil (perhaps a 3B) so as not to indent the surface of the clay, then, either with a brush or with a pen, begin drawing in Indian ink on to the surface: a brush is better for large areas. When the ink is dry you will be in a position to work into your black drawing with your tools, scratching, cross-hatching, stippling and texturing as required. The aim in a good scraperboard drawing is to preserve the broad masses of the black drawing, and yet to present a range of textures unique to the technique. It is very easy to correct the drawing on a scraperboard, since the black line mistakes may be scratched out, and the white line mistakes may be painted over with ink. However, each time you paint over any significant white line there is left a black channel in your drawing which tends to look unpleasant in the original. Try not to be feeble in your handling of the scraperboard drawing – and I do not mean by this that you should not be delicate. Think in masses, and allow your black areas to hold the textures together; do not use texture so completely that you are left only with a series of greys, with no sign as to how the drawing developed out of the medium.

54 Sgraffito in wax by six year old child

55 *Right* Fred Gettings, wax sgraffito after Klee. Private collection

A second sgraffito technique is involved with wax. To prepare the wax sgraffito surface take a piece of white card a little larger than the drawing you wish to make, and cover this entirely with a coating of wax. You may use either ordinary candle wax or any make of wax crayon which is light in tone – do not use black or deep browns, but try to make sure that the card is entirely covered with yellows, pinks and light blues. When you have covered the surface you must then scribble over the top of your drawing surface once more with black wax crayon so as to hide completely the first layer of lighter tones underneath. Now you will have three layers to your working surface: a first layer which is your card base, a second layer of light-toned wax, which rests on the card base, and a third layer of black wax, which rests on the light-toned wax, swimming on it so to speak, and neither adhering to this light-toned wax nor to the card. This dark top layer may be scratched off to reveal a line of colour or white, as the case may be, underneath. This sgraffito technique has little of the subtlety of the scraperboard technique, since extremely delicate handling is not possible, and the fine lines of wax tend to pull away. It is also a technique which is open to the same dangers as work on black scraperboard: quite facile drawings sometimes give a superficially pleasing effect even when no real artistic quality is present. In some ways, the most satisfactory graphic field for this sgraffito technique is in imaginative drawing, where the chance appearance of gay colours in the 'white' line helps to intensify the fairy-like quality of the design. The two examples of wax sgraffito (plates 54 and 55) illustrate this point, and also indicate something of the exuberance of handling which is possible when the scraping point slides over the wax, peeling off a sliver of black to reveal the colours beneath.

Another very interesting experimental line technique is that of monoprint drawing. In essence the technique consists of placing a sheet of drawing paper over the top of a thin layer of ink and then drawing over the back of this paper so that the pressure is sufficient to pick up a quantity of ink. In this way a reversed image of the drawing is obtained. The nature of the technique is such, however, that there is more than merely a mirror image of the original drawing produced – the technique involves the use of a rather special textured line which is richer than any line which can be obtained in any other

way. The example drawing by Sandra Henderson (plate 56) demonstrates this point – the line has a quality about it which is reminiscent of the burr of dry-point lines during the first two or three pulls. In addition the method of working results in 'accidental' surface textures where the paper has been pressed into the ink film while working at the drawing: with great care these accidental textures may be controlled and used to enhance the design.

The best working surface for this monoprint technique is a sheet of glass, though one may use a large sheet of card or a plastic surface. On to this sheet of glass one rolls a thin film of lino-printing ink (other inks either dry too quickly or do not dry quickly enough) of a sufficient thickness to leave a slight trace on the finger when it is dabbed on to the ink. If you roll too much ink on to the surface, then the transferred line will be very thick, and there will be little hope of controlling the accidental textures. You may test for the right thickness of ink by placing a sheet of paper over the film, and then peeling it off; if there is only a trace of ink on parts of the sheet when it is removed, then the film is of the right thickness for working. Over this deposit of ink you must place your sheet of thin drawing paper, and then draw over it either with a pencil, in order to leave a recording mark on the back of your mono-print, or with a stylus, which has the disadvantage of not leaving a clear mark to indicate what has been drawn. You may, of course, place two sheets of paper over the ink film – one to pick up the monoprint ink line, and the other to receive the pencil mark, though this does tend to thicken the drawing line.

56 Sandra Henderson (b.1945) costume drawing, monoprint.

57 Monoprint by seven year old child.

58 Ceri Richards (b.1903) *Owl* 1954, monoprint. Victoria and Albert Museum

Try not to rest your hand on the paper as you work, for every pressure leaves a recording smudge on the monoprint. Intentional pressures with the hand may be used as an integral part of your drawing – the dark areas of the curtain in plate 56 were obtained with the finger tip in this manner. A fairly viscous ink will give a heavier line than a more fluid one does – note for example the different qualities of the lines in the drawing of plate 57, in which a heavy litho-proving ink was used, and the line of Ceri Richards' *Owl* (plate 58) for which one presumes a relatively fluid or oily ink was used.

Another version of monoprint drawing may be done with wax. For this technique you prepare a surface of smooth drawing card with two separate layers of wax – either of various colours or in one single dark colour, and treat this surface as though it were a layer of ink. Very delicate lines may be monoprinted with such a wax surface, and there is hardly any tendency for the drawing to smudge and give accidental textures. If you leave only one layer of wax on your card, the monoprint will be very delicate, as the wax adheres to the card too firmly to be picked up in body under the pressure of the stylus. Two coats of wax ensure a sensitive response to pressure, however, since the second coat floats free of the card and wax, and is easily removed. The abstract monoprint in plate 59 was done as one of a series in which I was studying simple calligraphic forms, along the lines set out on page 11. The texture to the right and top of these simple lines I made by pressing down on the overlay paper a sheet of rough woollen fabric – the rest of the textures were obtained with the flat of my hand. You will notice that the lines are double: this is because I was drawing with an ordinary hairpin in such a way as to drag two edges of the metal to form one line.

59 Fred Gettings *Abstract* 1966, monoprint. Private collection

60 Caroline Richardson (b.1949) *Abstract* 1968, smoke drawing and various media

61 *Right* Caroline Richardson (b.1949) *The Three Levels* mixed media, including collage, ink and wax transfer

There are a variety of other linear experimental techniques which one might investigate, and which I will merely touch on here. Line collage may be done by cutting up old engravings, pieces of type, and line reproductions from newspapers and pasting these down, reassembling the old forms to make striking new images. The painter Max Ernst makes very clever use of this line collage technique, and an especially cunning piece of collage may be seen in John Piper's illustration (plate 44), for the straight lines of the lake in the foreground are actually made from pieces of music script which have been pasted down on to the drawing. Various other wax techniques should also be investigated – wax is for example an excellent stopping out vehicle for brush work, though not very suitable for pen work, as the wax itself tends to clog the pen nib. Many interesting textures may be obtained either by drawing directly on to a sheet of paper with an ordinary candle or by dripping hot candle wax directly on to your picture: when a wash of ink is run over the wax areas this is rejected by the grease, and a white texture is left behind. Different pictorial effects may be obtained by laying down such a bed of wax and then scratching into it with a fine point – when the ink is brushed over this the wax rejects parts of the ink, but the lines which have been bitten into the wax pick up the ink and give very rich textural effects. The drawings of Henry Moore

61

very often incorporate this simple wax technique with the purpose of suggesting textures and forms. Interesting tonal effects may also be obtained by burning a candle or match under a sheet of paper – this leaves a deposit of carbon black and very often singes the paper brown. The drawing in plate 60 is a good example of this textural experimental method. Caroline Richardson's other drawing at plate 61 is partly a collage, but it demonstrates yet another wax technique. If an area of paper is covered with candle wax, and this is then placed face down over newsprint and firmly rubbed with a pencil, a quantity of ink will be transferred to the wax, leaving a reversed image of the newsprint. The American artist Rauschenberg was particularly fond of this technique, and he used it to good effect in his famous series of illustrations to Dante's *Inferno*.

We have now briefly examined several different experimental line techniques, and it would be a good thing for your artistic development if you could undertake to do a few drawings in two or three of the various techniques already touched upon. Attempt a monoprint, a wax sgraffito and a scraperboard drawing before you move on to the next stage. A change of technique may often mean a change in vision, and a frequent change of vision is a prerequisite of art.

*A grey rock, said Ruskin, is a good
sitter. That is one type of behaviour.
A darting dragon-fly is another type
of behaviour. We call the one alive,
the other not, but both are fundamentally
balances of give and take of motion with
their surround. To make 'life' a
distinction between them is at root to
treat them both artificially.*

SIR CHARLES SHERRINGTON

Man on his Nature Cambridge University Press

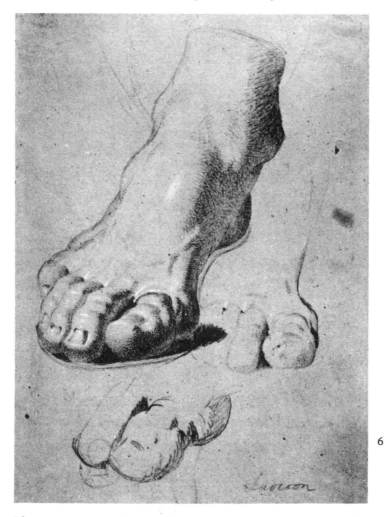

62 Benjamin Robert
 Haydon (1786-1846)
 antique study, pencil
 touched up with white
 on buff paper. British
 Museum

Drawing from nature

Although it is just about impossible for an artist not to draw from nature, since even when he chooses to draw 'from imagination' he is referring unconsciously to his private store of images which have an origin somewhere in nature, even so most artists distinguish between 'drawing from nature' and 'drawing from imagination'. Of course, the world of nature is a big thing; 'You have nothing before your eyes which is not filled with life', runs the Chinese maxim. Everything is a part of nature; a fur coat is as much a part of nature as a grizzly bear, a child's doll as much as the child herself, a Yorkshire slag heap as much as Mount Fuji. When one undertakes to 'draw from nature' therefore, one is faced with a bewildering profusion of subjects, and the temptation is to draw only what one wants to draw, without reference to what may be learned from doing a particular drawing. This is why it is especially important that a beginner be careful about his choice of subjects: he has to learn to distinguish between subjects which are good potential exercises from which he may learn something, and subjects which are really 'inspirations', carrying within them a direct experience which he feels must be recorded. The two are quite different.

The artist may regard any natural object or event as a basis for a graphic exercise, as a series of systematic studies in which something can be learned both about nature and about drawing, as Dürer intended, for example, when he dug up a sod of grass, carried it to his studio, and drew it many times from different angles. On the other hand, the artist may regard natural objects as experiences, which must be deeply felt rather than analyzed, and conveyed graphically as an experience, as Turner would do, being prepared to pop his head out of the window of a moving train to experience the speed of the train, or to have himself lashed to a ship's mast in a storm in order to experience directly the deep forces and drama of nature.

No one can be taught to draw or paint in terms of such experiences – ultimately the artist is alone when he comes to this level of experiencing nature or the force to create. On this level the artist is alone with only his technique as a link with the remainder of mankind – no one can help him, no one can teach him how to do it, simply because if he is doing it properly, then it has not been done before! However, with the more common experience of drawing – that which regards nature as a source of experience and discipline and permits us to choose a particular subject as a potential exercise – a considerable amount may be taught and learned.

Although we do not have in the west the same tight classification of subjects as they do in oriental art, most systems of art-education have subdivided the forms of nature into several subject categories which in fact present a series of graduated exercises, ranging in order of complexity from inanimate matter to living, and then to moving forms. The first on the list is usually called the 'antique' – the study of drawing from sculptures or plaster casts (plate 62), the idea being that the technical problems of elementary delineation, the representation of form, and the graduation of tonal contrasts which were at one time regarded as the very ABC of drawing, may best be studied

by drawing a simple, colourless, inanimate solid. With the antique the problems which face a student are simplified, since there is no colour, no life, no movement (and only too often no beauty) for him to struggle with; it was therefore, the argument ran, an excellent basis for discipline and for introduction to the problems of form.

The second on the list is the study of drawing from still life, that is from a motley collection of inanimate objects, either haphazardly grouped or carefully arranged in a formal order, to mark a progression from the white antique plaster cast, so that the student would be able to tackle a set of more advanced problems, involving composition, the problem of reducing colours to tonal equivalents, the problem of complex effects of chiaroscuro, textures etc.

The third on the list introduces a whole gamut of new experiences, for it involves the direct study of what is neatly classified as 'nature'; a field which is wide enough to incorporate plants, flowers, landscapes, animals and towns; everything from stags at bay to industrial landscapes. Of course, this introduces the artist to a wide range of problems of tone, colour, texture and form, all in a complex state of change, yet with the additional problems of there being a fuse of life in everything – an element which may not be rejected and which ideally should survive in the drawing to the extent that a drawing of a plaster cast of a foot should be quite different from a drawing of a living foot.

The fourth on the list, to which most artists turn with a sigh of relief, is usually approached only when a certain degree of technical proficiency has been gained, and the student knows (as Whistler puts it) which end of the brush to put into his mouth, and this is the subject of the human nude, which presents every shade of graphic problem which the artist is likely to face.

The convenient progression which this loose four-fold classification offers is usually dismissed by intelligent art teachers nowadays, yet few deny that it is a good idea for the student to start with a few simple exercises in drawing from nature before attempting to draw the nude. I presume that you have benefited from the previous chapter, and have already done several experiments in drawing with a variety of different techniques, and that you now find yourself in a position to draw the things around you in order to learn something more. However, before I begin to make any observations about drawing from nature, I would like to put in a word or two about the sketchbook, for this is the instrument which makes mock of all classifications of 'subject'; everything is suitable grist for the sketchbook mill. A good sketchbook, like a good artist, is classless: it may roam anywhere at any time.

It is difficult to say where sketching ends and drawing begins, but there is a world of difference between the two. The difference is one of what I can only describe as 'sense of audience' – the sketchbook is a kind of private visual diary, while a drawing requires audience participation for its very existence. The temptation with a drawing is to 'finish' it in order to show it to others; while sketching is a personal coming to terms with visual problems, and for a time the 'sense of audience' (and let there be no doubt, every artist carries with him a sense of audience), which may be likened to an Old Man of the Sea with a crippling leg-grip around one's neck, slips off, and one rehearses in private.

The words which the Victorian artist Müller wrote on the back of one of his drawings, 'Left as a sketch for some fool to finish and ruin', sets out the problem admirably, for very often finishing a drawing means ruining it.

Thus, it is almost true to say of drawing what is often said of painting, that one should stop the drawing just a little before it is finished! The truth is, of course, that one is rarely adding anything of value when one 'finishes' a drawing, and only too frequently a few lively strokes may catch the unique life of the subject better than a million dots and strokes may ever do. In a sketchbook you are free to study and to learn, to experiment, splash around, paddle in the ink if you wish, and because you do not feel that you have something looking over your shoulder all the time, you are involved with drawing rather than with showing off!

But the sketchbook is more than a place for lively studies, a place where the artist may rehearse his private fantasies; it is also a record of his own relationship to the world. A sketchbook is the artist's private diary of his inner progression; whether it is the simple notebook which Sir Francis Drake carried about with him to make little sketches of birds and trees which he saw during his travels, or the mountain of gigantic sketchbooks which Turner filled in his progress through Europe and his own inner being. There is usually more sense of the artist's development and real grasp, of what is going on in his private world, in his sketches than in his finished work. The beauty of sketching is that under the pressure of trying to set something down quickly, perhaps to catch an effect of light or the movement of a street scene, the subconscious of the artist sometimes takes control, and a drawing is produced which the artist himself cannot really appreciate until some considerable time after. Working at finished drawings very rarely allows this natural chemistry to take over – the sense of audience grips too tightly, and the artist does not 'let go' in the right way. The reproductions in plates 63 to 66 are taken from my own and students' sketchbooks, and these demonstrate something of the 'looseness' of approach which the sketch encourages.

63 Fred Gettings, leaf from sketchbook, 1958, pen and ink, brush and ink, and pencil

64

65 Fred Gettings, leaf from
sketchbook, 1961, pen and
Indian ink. Private collection

64 *Left* Fred Gettings, leaf from
sketchbook, 1956, pen and
sepia, and pencil. Private
collection

66 David Humphreys (b.1948)
Characters for a Private War
leaf from sketchbook, 1968,
pencil. Private collection

Look at the details of heads from Sickert's drawing (plate 67) and compare these with the nine studies which Barlow did (plate 68), and you will see something of the difference between the sketch and the finished drawing. Sickert's faces are the result of a candid analysis of what he saw before him, a rapid summary, with almost no thought of technique and handling, yet the individuality and life of each face is beautifully caught in a few deft strokes. Barlow, on the other hand, is involved with technique; these are not sketches, and they are not, strictly speaking, studies. They are drawings in a definite style, a style which is considered and careful, and which unfortunately takes precedence over the actual heads themselves. Notice how the eyes have been drawn in the same way, how the arch of the eyelid, and the thickness of the lid is the same in all cases; here we have an artist saying, 'Look how nicely I can draw; see how clever I am!' while with Sickert we have an example of an artist saying, 'This is what I see before me – look!' The two attitudes are very different. Sickert's work illustrates how in a drawing what is left out is just as important as what is put in – one thinks of how expressive some cartoons are with just a couple of dots for eyes and a single line for mouth. A good sketch works almost as much because of what the artist left out as for what he put in: a good sketch is a summary of what the artist sees and feels about what he has before him or in his mind. If you want to learn to draw you must learn to sketch, to abstract the essentials from the thing before you, and set these down quickly. You must look at the subject, feel its presence, so that when you draw the thing before you, then you almost become this thing. As the Chinese would say, to draw a bamboo, then you must become a bamboo – and that this is not just a piece of oriental mysticism we have the testimony of Ingres, who exclaimed, 'Have, in its entirety, in your soul, and in your eyes, the figure that you wish to present, and let the execution be only the realization of this possessed and preconceived image'.

Try to keep a sketchbook and to preserve through it this attitude of mind. Keep the sketchbook alive. Use a variety of media (plate 64), draw from nature (plate 65), draw from imagination (plate 66), make notes in it (plate 26), scribble in it, if need be, and make sure that it is a breeding ground for ideas, some of which may be verbal, some visual. Make it a part of yourself.

Drawing from the antique was encouraged in the past mainly in preparation for learning to draw from the nude and with the thought that by studying from Greek statuary one might imbibe the feeling for the Greek ideal of proportion which in itself was 'good' and 'beautiful'. But drawing something inanimate (plate 62) is not good training for drawing the nude, which is very much alive; and beauty does not necessarily reside in Greek canons. So forget about the antique, and try drawing a stone, or a piece of wood (plate 69). In fact, any natural inanimate object will do just as well. Choose something which interests you. It may be a smooth pebble from the beach, or a stone with a hole through it, or a rugged chunk of volcanic stone, rich in texture and form. Place this on the table and look at it. Do not start drawing immediately. Examine the form, texture, tone, lighting and so on, until you become reasonably familiar with the stone. Now draw it. Draw it first of all with a hardish pencil, perhaps a 2H, making as accurate a delineation as you are able. Be precise – convey the texture and shape which make this stone unique in the presence of every other stone. Think carefully and analytically about the object before you; perhaps you feel an urge to suggest its weight or

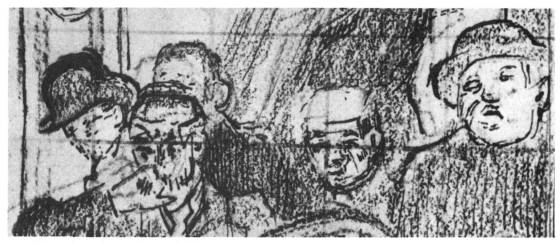

67 Detail from plate 77 *The Old Bedford*

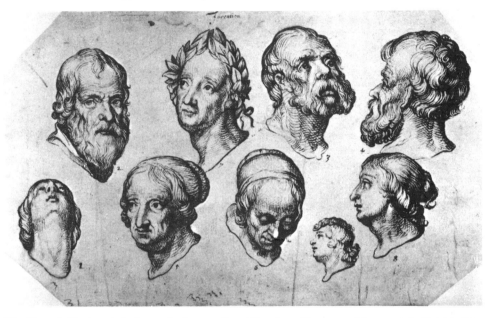

68 Francis Barlow (1626-1702) nine studies of heads 1968, pen and brown ink. British Museum

69 Detail from plate 65, pen and Indian ink

red whelk

periwinkle

conch

scallop

worm shell

large periwinkle

Traphon

sword razor shell

Scalaria

Murex

coffee-bean shell

pelican's foot shell

Pitariadione

70 Fred Gettings, illustrations from *The Wonder Book of Nature* published 1960 by Ward Lock Ltd

solidity, yet in trying to convey this to paper you find that the incidental textures tend to fight with the boldness and sweep which suggests the feeling of weight. You will therefore have to compromise at some point, and by doing so you will be reaching into the heart of drawing, which is the idea of compromise. Perhaps you may find it more satisfactory not to compromise in the same drawing, in which case do two drawings or even three, one to suggest the weight, one to suggest the texture, and a third to tie these together in one drawing.

After the stone, graduate to something a little more complex, perhaps a shell or a piece of coral. The graphic problem will now become more than dealing merely with weight and textures – it becomes one of openly struggling with delicacy of form, and involved with accuracy of description. Plate 70 is a fair example of how the problem may be tackled. I had to fill a page in a children's encyclopaedia with drawings of shells. Some of the shells I drew from actual life into my sketchbook, others I copied from photographs. My own version was meant for children, so it had to be simple, in a clear and

descriptive line, yet at the same time it had to be accurate and informative. This is why I chose a simple pen line technique, and depended on a sensitive outline to trace the contours, ridges and textures. In order to give a unity to the style of drawing I restricted myself to conveying the form of the shells with lines which followed the contours – a device which was particularly suited to shells, the structure of which is largely linear in any case, for example, the bulbous form of the red whelk is conveyed by the coils, the curling delicacy of the worm shell by the decorative twists, lines of textures, etc.

Make several studies of shells, perhaps attempting them in some material other than pen, yet maintaining an interest in the linear structures they exhibit. You will be able to make your drawing much more sensitive than my own, since yours will not be intended for reproduction, nor will it have to be simple enough for children to 'read' with ease. Try to convey the individual textures, as well as the structures of the shells – you may even try to hint at the 'colour', as I tried to hint at the irridescence of the *pitariadione*. I am not suggesting for one moment that you should draw your shells in the manner I drew mine, but you may look at my own picture to see how I tried to introduce an element of variety without allowing the quality of the page as a whole to suffer. Look, for example, at the different ways in which I have treated the mouths of the shells – a treatment which has depended very much on the *looking*, on what I actually saw. In the red whelk the outer delineating line varies a great deal in thickness, swelling thick and thin, to convey the particular nuances of the way in which the edge of the shell curves away from the eye. The similar line of the *scalaria* is much harder, more brittle, in accordance with the feeling of this shell. The lip edge of the large periwinkle not only swells from thick to thin in order to suggest the curve of the mouth edge, but in the middle of the curve this line disappears entirely, and a contour is suggested with a few flicks of texture. You too could set yourself the problem of making sure that the particular apertures of the shells are all seen and drawn in slightly different ways. Try not to make a mark without being aware of why you are doing it.

The transition from the antique to life, or from the stone and shell to life involves a whole new way of seeing. It is almost impossible for a beginner to sit down and draw directly from nature. The artist has to learn to see nature before he can draw it, and as John Constable pointed out, the art of 'seeing nature is a thing almost as much to be acquired as the art of reading the Egyptian hieroglyphics'. What I have to say apropos this is in fact very difficult to convey, and most students do not at first grasp its full implications. *We learn to see by imitation*. When this point is grasped, the full importance of the role which the artist plays in society is also grasped, and we see that the artist is charged with the important mission of revitalizing the vision and imagery of society.

Each time we open our eyes, we create a world which is unique to ourselves, yet we see this world through the eyes of a million artists. In learning to draw one is learning to see in a certain way – one is compelled to strip away the scales of prejudice which form a film over the eye and to peer into a pristine world. In this way the external vibrations, the light waves, are channelled through the eye to create in the brain a different image of the world. This is one of the secrets of learning how to draw – the secret is an alchemical operation of the eyes.

a

b

71 Drawings of sparrows by three different children

As the writings of Grotzinger have shown, a child does not 'learn to draw' so much as he uses drawing as a means of exploration.* As the child grows, almost all his education, both conscious and unconscious, is directed by imitation – he learns to laugh, walk, talk and even feel, from the people around him. He has to learn to draw in a similar way. Invariably, once he has learned the idea of image-making (not as natural a thing as one is tempted to think!) he learns to draw by copying the drawings of other children, or from pictures around him, and this usually means that he learns from very bad sources; from comics, for instance, or from bad art teachers, and he becomes given to producing ill-proportioned images of supermen or flying saucers, or uninspired drawings of twigs in jam jars. To illustrate what I mean I will take some drawings done by children at the beginning of the present century.

The three delightful drawings of birds in plate 71a were made by young children before they had been taught 'how to draw sparrows' by their art teacher. In spite of the fact that each of these drawings is delightfully in-dividual, with a wonderful relationship between the outlines of the birds and the spaces they occupy on the sheets, all too clearly this was not good enough for their teacher. He set out to teach them how they should really draw sparrows. This meant, of course, that the poor children would have to learn to draw sparrows in the way their teacher drew sparrows! Surely enough, he produced a series of hard-lined conventional images of sparrows, insipid in execution and quite without imagination, and set his children the task of tracing it, copying it, and cutting it out. By the end of a few weeks the children could indeed 'draw sparrows', as plate 71b shows – but how uninspired are these 'adult' versions compared with their original visions. The children before this exercise might well have sided with Blake and seen an angel in the flight of a pigeon, but after the exercise they would never see a bird again, except as a wire outline symbol.

The tragic tacit assumption behind the exercise set these unfortunate children was that *there was only one way to draw a bird,* while the truth is that there are about as many ways of drawing birds as there are different kinds of people and different kinds of birds, as plates 23, 72 and 73 will confirm.

* It is surely this which such artists as Klee have in mind when they speak of the value of learning to draw once more like a child. See *Scribbling, Drawing and Painting* by Professor Grotzinger. Faber.

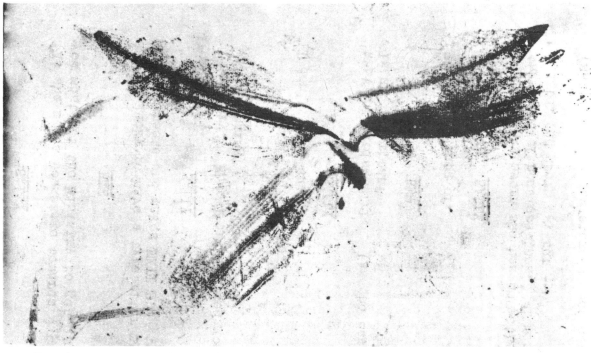

72　Fred Gettings *Flying Bird* 1966, roller drawing

73　Eduardo Paolozzi (b.1924) *Fishermen and Gulls* 1946, Indian ink and wash. Victoria and Albert Museum

74 Steinberg (b.1914) from *The Labyrinth* published 1961 by Harper and Row

All this talk about how children learn to draw is not very far removed from our own problem. Adults also learn to draw and increase their graphic scope by the study of other artists. It is not so much that one learns precisely where or how to put the lines (as young children learn to draw) but that one learns to *see* in a distinctive way. The difference between the faces of Sickert (plate 67) and Steinberg (plate 74) is not merely a matter of technique or the placing of lines – it is a difference in a way of seeing.

Ways of seeing may be grafted on to one, just as the ways of drawing (and therefore seeing) sparrows may be grafted on to young children, and all this is a matter of temperament. An artist with a love for humanity may be more easily persuaded to adopt Sickert's vision of the world, for example, than the vision of Grosz (plate 75). It is a matter of temperament, a matter of personal vision. And it is this personal vision which one must try to develop through the medium of drawing. The real aim must be to find your own personal way of setting down your unique personal vision of the world. In the initial stages this comes down to familiarizing yourself with as many different styles and graphic visions of the world as possible, copying and learning as you go along. If you like a particular drawing, then open yourself to its influence, copy it perhaps, but certainly allow its vision to merge with your own, to become a part of yourself. This cross-fertilization of visions and techniques is essential for artistic growth. In this respect we must learn to draw like little children draw before their personalities are so dutifully repressed, striving to express and explore our own individual vision without shame or fear of technical incompetence, yet being constantly open to learning from what has been done before.

There are only three ways to learn to draw: the first is under the guidance of a competent teacher who wishes you to grow into your own personality; the second is by a close study of nature with an attitude which permits you to make a leap into the dark in order to learn something new; the third way is by intelligent copying. Let us look at the implications of these three methods.

The superbly delicate and sensitive pencil drawing of a bird in plate 23 was done by one of my young pupils whom I had encouraged especially to develop a sense of imagination. For some time she had been drawing startling 'realistic' versions of birds, relying almost entirely on photographs of other artists' work for her inspiration. Realizing the dangers (mainly the danger of her imaginative faculty being swamped by learned gimmicks, and too great a reliance on other men's vision) I put her through a fairly intensive course

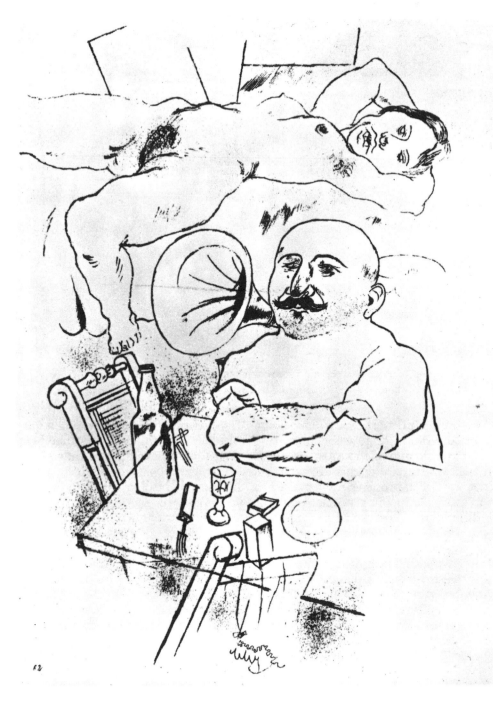

75 George Grosz (1893-1959) *Athlet* 1922, pen and ink. With kind permission of the estate of George Grosz, Princeton, New Jersey

of drawing 'imaginative' things, such as dragons, monsters, and so on, in order to lubricate her imaginative faculty and to release her from what Klee called 'the quicksand of the world of appearances'. To judge from the delightful balance between the imaginative elements and the realistic elements in this drawing, the experiment was a success. More important still was the fact that, for a while, the child had found herself, had been able to orientate herself to the world in a new way. The drawing stands as an example of how responsible guidance may help a person to grow towards himself.

76 K. K. Lau, photograph of birds in flight, 1968

Leaping into the dark is expressive of an attitude of mind which is extremely difficult to describe, and quite impossible to impart to another person, yet it is one of the most interesting methods of learning to draw. I set myself an exercise in this direction some time ago when I decided to find a new way of expressing movement – in this case, a bird in flight. I did not want to make recourse to the usual gimmicks of graphic methods for suggesting movement, and I had in mind what the Futurist Manifesto of 1912 had said about this kind of problem: 'A moving horse is not a stationary horse, but a horse in motion; that is quite a different thing, and must also be expressed as a different thing'. The resultant drawing (plate 72) was an attempt to suggest the feeling of a bird in motion (see plate 76): it was made partly by drawing with the edge of an ordinary lino roller, and partly by pressing leaves into ink and 'printing' them down on to the drawing. I did this because I find it easier to make a creative 'leap into darkness' with a technique or material with which I am not familiar.

Perhaps you would like to take as your next exercise the double task of drawing a perched bird as realistically and sensitively as possible, and then drawing a bird in motion. For the latter experiment you might care to use a material or technique which you have never used before, to see if this helps.

And now for the third way of learning to draw: by copying. I am constantly surprised by the reaction of most of my students when I suggest that they should spend some time copying master drawings. The reaction is strong, I suppose, because there is a feeling that art should be involved with the expression of self, one's own personality – a feeling which is a vestige of the out-dated Romantic image of the artist. The idea that an artist should not copy other artist's drawings does not bear examination: a rich personality always consists of accretions of other personalities. There is no danger in intelligent copying, and my experience shows that the only unintelligent form of copying is copying inferior artists!

The extent to which the mediaeval apprentices copied is well known; they were trained to submerge their own personalities in that of their masters, in the certain knowledge that once they had learned to draw well in one way, they would be in a better position to develop their own personal vision later. This tradition of copying in order to learn to draw survived in one form or another until well into the nineteenth century. Hesketh Hubbard, in his account of the training of Victorian artists* wrote:

... the method of learning to draw landscapes in those days was by copying specially prepared drawings graded in complexity. Drawing was rightly recognized as a form of handwriting and both arts were taught by copybook. . . . Before adventuring to sketch in the field, the student learned a graphic touch for foliage, cloud and masonry. He learned, too, to compose his motifs, conventionally perhaps, but resulting in an agreeable composition. He learned picture-making side by side with drawing. This method naturally led to a certain similarity amongst the work of the majority of the pupils, but it had distinct advantages. It was the means of perpetuating a tradition long enough for it to mature and its possibilities to be explored and worked out . . . This tutorial method ensured a sense of style in both handling and design, and no doubt accounted for the high standard of much of the work produced by amateurs in the first half of the last century. I doubt whether it is an exaggeration to say that pictorial composition received a great setback when this method of teaching was abandoned. The more adventurous spirits naturally came to express themselves individually, but they benefited by their early background, which gave them the assurance of men proud of their ancestry. It carried them forward on the full flood of a sound and living tradition.

Later on in this same book Hubbard goes on to say that the method of copying fell into disrepute because it came to be taught in a wrong way, 'slavish imitation took the place of translation or interpretation'. But before this degeneration took place, artists copied with their eyes open, not blindly. 'They produced a drawing in the manner of Canaletto or Cozens; they did not counterfeit any given drawing', and they used old master drawings as standards and correctives for their own work.

Intelligent copying is therefore not only advisable – it is even necessary. One word of warning, however – try always to copy from originals, not from reproductions.† Most museums and libraries have facilities for copying. Your aim should be to learn; to learn something about the style of an artist you are fond of, and something about your own limitations and possibilities. Try to see how the other artist felt, and understand how he saw the world. Look, paraphrase, analyze, simplify, abstract and reconstruct – but never merely imitate. Copying, that is *intelligent* copying, is an art in itself.

If you resist the temptation merely to learn to draw as others draw, and succeed in learning to draw, however badly, like yourself, then there is no danger in copying at all. Copying other drawings, either *in toto* or as isolated fragments, is after all only the equivalent of the close reading which thinkers and philosophers indulge in every day – copying is a visual exchange of ideas, just as reading should be a literary exchange of ideas.

* Hesketh Hubbard, *Some Victorian Draughtsmen*, Cambridge University Press

† There are several reasons for not copying from reproductions, the main one being that reproductions are always far removed from the original in quality; they are rarely on the same quality of paper as the original, never in the same medium, and rarely of the same size. In addition there is always a considerable loss involved in the reproductive technique itself.

Now we may return to a consideration of drawing from nature. Here, of course, the subject is the thing, and it deserves some thought. It is both the inspiration for the drawing and a danger to it, for while it is the source of the artistic impetus, it may hypnotize the artist into bad drawing. The artist may easily become so entranced by the subject he has set himself that he will forget that he is doing a drawing of it, that he is *interpreting* it rather than merely eulogizing it! Yet another dangerous attitude to the subject is the one which compels the artist not to look at it while he makes his drawing! This sounds so fantastic that it is hard to believe. However, it is all too common. The artist, having chosen a subject, is usually very eager to set up his easel or drawing board and settle down to filling his paper with pencil strokes without troubling to look at the subject carefully and without asking himself what he is trying to do. The whole secret of drawing from life resides in the initial looking, and I recall that my art master would bring this home to his class by making us stand for at least five minutes examining the nude before we were allowed to put pencil to paper. In this way we clarified our aim.

The need for thought, the need to be in the right frame of mind, the need to be clear and selective, becomes evident to anyone who has tried to draw with any real seriousness. One cannot put down on paper all that one sees – the world is much too complex for that. The landscape, for instance the one which Cameron drew (plate 46), has trees in it, and one of those trees has a million leaves; on one of these leaves is a caterpillar, which is crawling down one of the vein ridges of the leaf . . . You cannot draw the valley *and* the vein ridges in one drawing. You have to be selective – there is never any question of 'drawing what you see' – only a raw beginner would try to do that. So obviously the sensible thing to do before you begin to draw is to decide precisely what you are going to put into your drawing.

But the subject is more than a complex of problems; it is usually the inspiration for your drawing. The artist sees something which, as they say, inspires him. He feels a love which burns within him, and because he is an artist he feels that he must convey this love to paper. In such extreme cases of inspiration it is not so much a case of the artist choosing a subject, as the subject choosing an artist. Such an intense inspiration may almost overpower an artist, and may drive him to great lengths – one thinks of Holman Hunt making his long journey to the Holy Land in the last century, all to make drawings of a real scapegoat in a real desert, and to catch sunstroke the while, but bringing back the drawings he required. One thinks of Reuwich, who also went to the Holy Land, travelling with the author Breydenbach in 1485 or thereabouts to prepare original drawings of towns, costumes and the Holy Sepulchre for a book – and this at a time when books or manuscripts would offer the one same drawing to illustrate the topography of Damascus, Ferrara and Spain. What an effort and journey in those times, just for the love of a subject.

Yet this kind of effort is necessary when the subject itself becomes the source of the picture, when, for instance, you are drawing a storm, and you don't really know what a storm looks like, and you happen to feel the same urge as Paul Cézanne who said that he did not want to be right in his drawing 'theoretically, but in the presence of nature'. This urge towards fidelity becomes the inspiration and the real subject – not the scapegoat in the desert, or the Holy Tabernacle in Jerusalem, for these are merely outward forms.

77 Walter Richard Sickert (1860-1942) *The Old Bedford* mixed media. British Museum

If you look at Sickert's drawing of the old Bedford Music Hall (plate 77), which he did shortly before it was burned down, you will see another side to this question of subject. We know that Sickert loved the stage, and above all the music hall, even that he was a bit of an actor himself – yet, after examining some of the hundreds of sketches he made in the theatre we begin to wonder if he ever watched the presentation on the stage at all, so engrossed did he appear to be with the audience and his sketchbook ('an artist must always be rehearsing' was one of his dicta, and of course he was speaking of the sketchbook). So in view of this it comes as something of a shock for us to realize that

his subject was not really the audience at all, that although he clearly loved these characters, their vulgarity and their ease, he was really studying structure. In the drawing in plate 77 we may see this total fascination with the architectural structure of the boxes, the moulding, the details of the railings, the mirror frames and so on, his attempts to relate these in a satisfactory abstract relationship on his sheet of paper: yet in spite of this there is none of the dehumanization which is so common in later abstract pictures, for those eight ovals to the right are still distinctly human faces.

Sickert's subject was abstract forms and relationships. This obsession with the abstract runs through almost all his work to such a degree that his apparent 'subject' becomes irrelevant. He would tackle a drawing of a terrace of Georgian houses, or of a street scene in Dieppe, or of a nude woman on a bed in some dingy back-street of Islington, with the same impartial interest in structure. In each one he would be chiefly interested in the structural relationships which these subjects offer – in the angles of the houses, the patterns of the cobbled streets, the rhythm of the figure and the abstract pattern which the woman's pendulous breasts make with the door jamb behind her, as she stands immortalised for an instant because her body is being sectioned off by the upright posts of an old brass bedstead, and she has become an abstract relationship of forms rather than a living figure.

But perhaps this kind of inspiration is rare. It certainly comes at the most odd moments. One often finds that after choosing a subject, almost at random, because one wants to work at the graphic problem which it presents, then inspiration suddenly comes. This is why you can start by drawing almost anything. Therefore draw what you love. And if you think that you don't love anything, then draw yourself! The main thing is to settle down before a subject, any old subject, and then examine it carefully with a view to drawing. You will find that so far as learning is concerned the thing we call inspiration is almost irrelevant – the important thing is to get down to drawing.

Half the battle of drawing is already won if one *wants* to draw something, if one is inspired. An interesting experiment therefore is to put yourself in a position where a little self-discipline is required, and try to make a drawing of something you feel no real inclination to draw. For example, instead of placing a pot of flowers on the table, and then drawing these, do something else: put the flowers on the table, by all means, but then draw the chair that you were going to sit on. This last suggestion might appear to be facetious, but in fact there is a lesson to be learned from it – perhaps one of the most important lessons that a beginner may hope to learn. If you simply sit down and draw the flowers, then you might well finish up with a pretty drawing of flowers, but it is unlikely that you will have learned anything. On the other hand, if you are able to meet the challenge, and attempt to draw that chair, then you might learn something about drawing, and you will be able to draw even flowers better in the future. As objects, a pot of flowers and a chair are two different things, but taken as a subject for an artist interested in, say, flat pattern, then the two are almost the same thing. One may study the shapes which the wooden structure of the chair creates against its background and these will be very little different from the delicate shapes which the leaves make against the background of flowers and tablecloth. Your subject will be neither the chair nor the flowers – your subject will be flat shapes. Do at least one drawing along these lines – put two or three objects on a table, perhaps a

78 Details from five fashion drawings

loaf, a bottle, a teapot and so on, and make a study of the shapes which these create around and about them.

By now we should have learned something about the relationship which exists between an artist and his subject. We must bear this in mind as we follow a different set of practical experiments which are designed to deepen our awareness of our attitude to drawing.

Draw a face; from life or from imagination, as the spirit takes you. When your drawing is finished to the best of your ability, put it aside for a while and draw yet another face, using the same medium. Now compare the two drawings. You will see that even though the two faces may have been of different people there will be considerable resemblance in some of the details – you may for example have constructed the mouth in the same way, or given the same emphasis to the eyes, drawing the lashes or the lids in the same way. If you look at them you will be sure to find some surprising similarities in the same way as we found stylistic similarities in the Barlow studies in plate 68. Now that you have noted one or two of these similarities between the drawings, draw one of the faces once more, but this time make a serious effort to invent a new way of presenting those items which you drew as 'formulae' in the other two portraits. You will see how difficult it is. The five heads (plate 78) show how a fashion designer, who is after all not terribly interested in the faces of her models, attempts to create a degree of variety in the faces, yet at the same time makes use of fairly abstract lines to express the faces, almost as if she has learned a series of formulae to which she sticks for each version of a face.

We rely a great deal on a set form of drawing things. We learn to draw eyes, noses, mouths, in one particular way, and although we adjust these symbols to suit the individual face, we find it very difficult, or even unnecessary, to invent new forms. It is surprisingly difficult for us to look at a subject, at a human face for instance, and analyze it carefully, and then discover intelligent graphic equivalents for what we see. The temptation is to set down 'what one sees' by relying on a set of visual associations and learned formulae, like the fashion artist. Insensitive artists even go so far as to call this *style!* But this is not style, this is not art – it is merely a sort of memory game played by a visual species of parrots: it is perfectly acceptable for such work as fashion drawing or for cartoon drawing, but it is nothing to do with the business of drawing from nature.

If you look once more at the detail from Sickert's drawing in plate 67 you will see that although eight faces are visible, not one of them has been drawn in the same manner. A few ink strokes in some cases are sufficient to portray a face; a little scribble, and the addition of a fleck or two of litho chalk in another case, and quite a different face is drawn. Now although each face is the face of an individual, and is therefore treated individually (and this in the dark of a theatre, to boot) Sickert has succeeded in drawing eight faces which show the same rapt attention to what is going on on the stage. In other words, without changing expressions he has managed to create eight distinctly different faces. This is what an artist of real genius may do with a bit of conté crayon, litho chalk and a pen – he may catch the essential differences which distinguish each face, yet relate these faces to the one emotion they share, while treating of the whole group as an almost incidental series of ovoids in an abstract setting of structures.

If you are still finding difficulty in drawing faces which are differently constructed, you should examine the two women's heads in Steinberg's illustration in plate 74. Here we can see an example of an artist going to extreme lengths to be inventive while preserving the general structure of a face – he even goes to the extent of giving one of his faces two mouths, one to represent a smiling face, the other to represent the frowning face, resulting in a brilliant graphic statement about the nature of the face as a mask. This is good social comment: only the mouth changes in Steinberg's world, for the eyes are dead, or frightened of expressing themselves.

George Grosz had a different vision of the world, and has developed it to a high pitch of sensitivity. The faces of the people who inhabit his drawings are very different indeed from those of Steinberg, for their faces hide nothing (plate 79). Just as the dresses of the women do not hide their nakedness under the stripping gaze of the men, so the faces of these people do not hide their hate, fears and desires which are in their bodies. The faces are almost animal-like, yet do not quite resemble animals. You can see the inner madness of the people – the goofy, harmless madness of the simian character in the bottom right; the gluttonous tension in the pig-like man just behind him, the sexual posture and leering mask of the man at the table, who is so completely obsessed with his fixations. The worlds of Steinberg and Grosz are far removed from the gentle world of Sickert's audience, yet they are just as telling, and unfortunately just as real.

Your next practical exercise should be fairly evident; draw two faces – one which represents mask-like repression, and one which catches the very

79 George Grosz *Schonheitsabend in der Motzstrasse* 1918, pen and ink. With kind permission of the estate of George Grosz, Princeton, New Jersey

epitome of what is going on within the man. Perhaps you could choose one of the seven deadly sins as the subject for your emotions, and try to draw the facial expression of this – but any strong emotion will do. Examine the drawings of Grosz and Steinberg as you work, for help and inspiration.

Learning to *feel* about what one sees is bound up with learning to be a real artist. In order to see what I mean you might try the experiment of drawing a subject of a highly emotive nature. Whichever passion or emotion you decide to express through your drawing, try to *feel* it deeply within yourself. Catch the emotion, as it were, and let it run down the ferrule of your brush, or leak from the tip of your pencil. Transfer this feeling to your work. When you have succeeded even once in communicating with your subject in this way, and have transferred the emotion to your work, you will find that a remarkable change will come over your attitude to drawing: you will see the truth of what Paul Klee said, 'The artist knows an infinity of things, but he doesn't know them until afterwards'. This 'infinity of things' is contained within your subconscious, and your effort should be to let your subconscious knowledge come out unimpeded. I am not being airy-fairy about this: in both China and Japan this concept of feeling into the subject, *being* the subject, having an empathy with it is regarded as a prerequisite to good drawing.

80 Pen, ink and wash drawing of a crying face by an eight year old boy

Your first experiments in this direction may well be involved with drawing a crying face. The example in plate 80 was the end product of a lesson in *feeling,* the aim being to show the children how to catch a feeling and put it into their drawing. During the course of the first lesson I had shown the class reproductions and slides of drawings by master draughtsmen of 'crying subjects', such as Picasso's series of almost abstract drawings, Rembrandt's reed drawing of a crying child, Baskin's *Weeping Man* (plate 81) and Phil May's *Crying Child* (plate 82), and much good work had been done in the spirit of these drawings. However, it was not until I told the class to try and catch the feeling of grief for themselves by pretending to cry, and to watch what happens to a face when the person is crying, that any real progress was made. The best results were almost abstract forms – certainly as distorted as the faces of Grosz or Baskin, yet a real feeling of grief was present in every single drawing.

81 Leonard Baskin (b.1922) *Weeping Man* 1956, brush, ink and lithographic chalk.
Worcester Art Museum, Massachusetts

82 Phil May (1864-1903) *Crying Child*, pen, ink and litho chalk. British Museum

Try this experiment. Examine first of all your own face in the mirror – see what actually happens when you simulate grief. Then examine the reproductions of Baskin and Phil May (plates 81 and 82). Note how the coarse textures of the calligraphic texture of eyes and forehead in the Baskin express the screwed-up tension of the *feeling,* and compare these brush and pencil slashes with the eyes in the drawing by Phil May. You will see that it is almost impossible to express the *feeling* of crying in a realistic manner. The need to express feeling is met by distortion. Intense emotion always leads to distortion. This distortion need not be extreme, but it is evident that if you are wanting your lines to convey emotion, then they must depart somewhat from the role of 'realistic description'. It is because of this that Van Gogh could write of the distortion in his own powerful work, 'my great longing is to make those very incorrectnesses, those deviations, remodellings, *changes of reality.* In order that they may become, yes, untruth, if you like, but more literal truth!'

This is probably an appropriate place, while we are on the subject of faces, to have a brief look at portrait drawing, for here we have a well entrenched formal exercise in which one is constantly coming up against one's limitations and prejudices.

Short of drawing someone from the back, there are three interesting angles from which one may choose to draw a formal portrait: profile, full face and 'three-quarter'. The profile (plate 83) is perhaps the easiest to do, for the hard outline of the face is usually highly characteristic, and is very easily reduced to 'line' – witness the 'likeness' which may be seen in a silhouette. The disadvantage with the profile is that the sitter, usually quite unacquainted with this view, fails to recognize himself from his portrait. Although likeness is not the be all and end all of portrait drawing, it is very important; and very often, so far as the sitter is concerned at least, it is the most important thing. However, there is one fascinating problem which the profile presents to an artist, and that is the nature of the facial line. The tripartite division into forehead, nose and the part below the nose to the chin: three 'equal' depths in the theory of classical proportions, which each present different graphic problems because of the planes at which they disappear. The profile forehead pulls away from the artist at a very sharp rate – a slight movement of the artist's head to left or right changes a great deal what he can see of the forehead. The problem is for the artist to choose the kind of line which conveys this sense of depth, of the 'disappearing' of the contour at a sharp angle to the eye. The nose is almost a ridge, hard and unmoving, and of quite a different nature of line, it is perhaps easier to draw, since even a wire-like line will catch its essential nature, but the quality of line must not be too different from that of the forehead, for reasons of graphic unity. The complex nature of the mouth and chin in a profile is again quite a different problem. Most artists find this the most difficult part to draw – mainly because they have not studied the structure of the lips and chin sufficiently, and also because they confuse the drawing of the *form* of the lips, the delicate velvety softness, with the drawing of its *tone.* Be wary of this problem; the relationship between the heavier tone of the lips and the surrounding skin is much more subtle than one might think. It is lack of awareness of this which results in so many drawings of faces with lips which look as though they have been 'stuck on' to a mouthless face, or as though necrosis has set in. Another point to watch when drawing a profile is the question of the depth of the skull. We are so used to seeing

83 Peter Paul Rubens (1577-1640) eleven studies of heads, *c.* 1619, pen and sepia, and grey wash over black chalk. British Museum

people face-on that we do not realize just how far back the skull goes, which is always further back as an ovoid than the width of the face. Notice how far back the ear is from the face – usually about twice the distance back from the root of the nose to the corner of the eye, and realise that this point usually indicates the centre point of the profile head!

The full-face drawing presents an enormous range of problems to the artist. The unobservant layman is usually under the impression that one half of the face is a mirror-image of the other half, but, of course, this is nonsense (see plate 39 for instance), and the artist must examine his model carefully to determine the differences in proportion, angle, depth, and so on which exist between the various parts. The main graphic problem with the full-face drawing is that while in general terms the face is 'flat' or moon-shaped, the nose sticks out at least an inch, and it is quite difficult to suggest this depth of the nose in contrast to the more gentle rotundity of the remaining face. Inferior artists will rely on shading, on carefully drawing in a cast shadow to indicate the height of the nose, but a more competent artist must rely on his grasp of form. In some ways it is not even necessary to put too much effort into suggesting the height of the nose, for the eye of the observer will interpret it as being a natural nose provided that the drawing itself does not imply otherwise: all of which suggests the saying, 'the least drawn about the nose, the better!' Beginners usually have problems with eyes. Most frequently they draw them as surface things, or, because they realize that there is such a thing as an eyeball, they draw half a ball popping out of a slit in the face. Actually

84 85

if you look at the eye, you will find that it is contained in several layers of
pouch, and that the upper and lower lids fold over the ball to protect it,
usually jutting out just about level with the protuberance of the ball itself.
This structure must be expressed by the artist in a full face portrait. Rubens
expressed it very well in the portrait of his first wife (plate 84). Note also how
Rubens has drawn, even emphasized, the difference between the two eyes,
and the two halves of the mouth. The other important thing which one must
attempt to introduce into a full-face portrait is a sense of the rotundity of the
head – another thing which Rubens has expressed so well. Notice also
Rubens' subtle lighting; the very smallest area of shading to suggest the dark
shadow is sketched in to the left of her face, and even this is used more to
suggest the plane of the rotund head than to suggest the chiaroscuro itself.
The position of the lighting would suggest deeper shadows under the eye-
brows and under the chin, but Rubens chose not to put them in, sacrificing
the sense of light and shade to the feeling for form. See also the mastery of
handling around the mouth – it is not a thing divorced from the structure of
the face, but is related so well to the muscular structure around the jaws that
it is difficult for one to say precisely where the 'mouth' ends and where the
skin and dimpling begins. This portrait of Elizabeth Brandt for the deftness of
handling (it is in three different colours of chalk, with touches of pen and ink),
grasp of form and expression of life and personality must be one of the most
remarkable formal portraits ever executed.

A three-quarters view (plate 85) is often the most satisfactory for formal
portraiture, for it presents the face in a way which demonstrates a wide array
of personal characteristics such as the length of the nose in relation to the face,
the angle of the jaw, and so on, and yet it permits the artist to avoid the
problem of facial asymmetry, which is so evident to anyone who cares to
examine a face but which is often repugnant to the sitter himself. Even so,
in this connection we may note that Holbein goes to considerable lengths to

84 Peter Paul Rubens
*Portrait of Elizabeth
Brandt c.*1625, black, red
and white chalk, with
touches of ink. British
Museum

85 Hans Holbein (1497-
1543) *John Fisher* pen
and black ink, with grey
wash over red and black
chalk on pink prepared
paper. British Museum

86 Fred Gettings
The Artist's Wife 1964,
pen ink and pencil.
Private collection

record the different sizes of the pupils of his sitter's eyes (plate 85). The best
advice one can give an artist intent on producing a three-quarter formal
portrait is to suggest that he takes especial care in establishing the precise
angles which the lines of nose, chin and eyebrows hold to each other. My
chief aim in drawing the portrait of my wife (plate 86) was to suggest the
rotundity of the head, and its weight on the hands with the minimum of
lines. Hands are sufficiently individual in shape and 'expression' to be re-
garded as legitimate quarry for the portrait artist.

One point about portraiture itself; it is one of the most difficult arts to
practise, for it demands a great deal of knowledge and restraint on the part of
the artist. The need for knowledge is perhaps self-evident, the need for re-
straint less so. For a start you must remember that you will be interpreting
the face you see before you in terms of lines – for example, where there is no
line, not even a crease, under the eye of your little girl model, you will have to
draw a line, and the result is that unless considerable delicacy of handling is
exercised, the portrait will look older than the model. After all, an actor who
wishes to appear older on the stage paints just such lines on his face. You may
see how a master solves this problem if you examine once more the portrait by
Rubens (plate 84), for in spite of all appearances there is scarcely a con-
tinuous line on the paper, except of course in the handling of the hair, where
line is surely permissible. A final point about portrait drawing – remember
the sitter! While you are drawing you are doing something interesting, and
time will pass very quickly for you: not so for the model, for whom a minute
will drag like an hour. Do not keep an inexperienced model sitting for more
than twenty-five minutes at a stretch, and allow at least ten minutes interval
between the sittings. As Hilliard, one of the greatest portrait painters of them
all, wrote, 'Discret talke or reading, quiete merth or musike ofendeth not,
but shortneth the time and quickneth the sperit, both in the drawer and he
which is drawne'.

It is absurd and a spiritual betrayal to copy directly from a model. We must also express the invisible, that which moves and has its being on the other side of a static object, that which is to the right and left of us and behind us. We cannot be content with a little square of life which is artificially enclosed like the stage of a theatre.

From the catalogue of the Futurist Exhibition of 1912

87 Illustration from Aldrovandus' *Monstrorum Historia* 1642 edition, woodcut. British Museum

Drawing from imagination

The would-be artist often takes it for granted that it is possible to draw one thing without being able to draw another. 'I can draw faces, but I can't draw birds . . .' is one fairly common argument on these lines, or 'I can't for the life of me draw eyes . . .' Such statements are tantamount to admitting that one cannot draw at all. It simply means that faced with a particular graphic problem – that of drawing birds or eyes, for example, the artist retreats, perhaps believing the while that he can draw almost everything else. I must repeat; drawing is an attitude of mind, it is not concerned with regurgitating learned formulae, of being able to draw hands, but not fingers, of being able to draw figures, but not cars. It is obviously absurd to think that one can isolate the subjects around one into such categories as eyes and face and the like, as though these have a separate autonomous existence: the eye is a ball and it rests in a socket, which is on a face, and must be related to this face. The face itself is on the front of a solid skull, and is constantly changing with the emotions which surge through the body upon which it is balanced. And this body walks on the ground at some point of the earth, which is itself spinning madly in space. Everything is too intimately connected to be separated out so glibly with such words as 'I cannot draw eyes'.

Equally silly, is the idea that it is possible for one to draw from life without being able to draw from imagination, or vice versa. Obviously, one *prefers* one kind of drawing to the other, but they are by no means mutually exclusive. In any case, it is not so easy to decide at what point one is drawing 'from life' and at what point one draws from imagination: the two are the woof and warp of life, are enmeshed in the very fabric of an artist's being.

One interesting experiment you may try in order to study this question of imaginative drawing is to try making a picture of an animal you have never seen. Try drawing a zingomort, for example, a beast which you have probably never encountered before. The zingomort has the tail of a small fish, the head of a pig, and is covered all over in scales and eyes. It lives on dry land, and eats fried onions. Try your hand at this – don't worry about the media – use pencil, and above all, don't worry about form. Restrict yourself to drawing the content of this strange creature as you imagine it to be.

You may well end up with a drawing something like the *Sus Marinus Monstrosus* (plate 87), which was offered by the zoologist Aldrovandus in the sixteenth century as a genuine creature. You may not have created an exciting drawing, but you will at least have learned one thing through your attempt – that it is extremely difficult to invent something new. The temptation is always to put down what one already knows; to build a zingomort from a pig and a fish with little or no attempt to relate them morphologically. Put away your famous zingomort and leave it without looking at it for at least a week. At the end of that time, using the same medium, and without looking at the drawing, make a picture of a fish and a pig. Now compare the three drawings, and you will see exactly what I mean the difficulty of inventing something new. The imagination is more limited, more given to relying on visual

formulae than we think! You will probably have drawn the ears of the pig in the same way, or the eyes or snouts, as though these elements could only be drawn in one way. Now put away these three drawings and once more draw your zingomort, this time making sure that you are being inventive. Try to change as many elements as you can, yet still preserve the basic structure of the fabulous beast. Consider every element as you come to it, trying not to draw a single line without giving it some thought. If you find that you can do this, then you are on the way to learning something about drawing.

You will have seen by now just how difficult it is to invent new forms, and you will be in a position to admire such sketches as those in plate 66, which, in spite of their resemblance to Breughel or Bosch drawings, are organic forms of considerable invention. This fact that it is difficult to invent leads us to one position, if we are honest, and that is to the need to clear ourselves of visual prejudices as much as possible. We must do this if we wish to become artists.

When faced with a new graphic problem, or with one which we have not struggled with sufficiently, our immediate response is either to trot out a stock piece of graphic, or to say, 'I cannot draw that!' We can imagine the sinking feeling in the stomach of the artist who was originally asked to make a drawing of a crocodile which he had obviously never seen (plate 88). The animal he finally ended up with is not a very reptilian crocodile, admittedly, but it has much beauty of line, and in any case the monkish artist was interested in other things than zoological accuracy. The moral, so far as we are concerned, is that he did not say, 'I cannot draw crocodiles . . .' – he got on with the job as best he could. He did not allow content to restrict form, or his own inertia to prevent him from trying. There is a world of difference between saying 'I can't draw crocodiles', and trying to draw the beasts. It is a question of integrity.

It is true that even a trained and professional artist when faced with a new subject will feel a similar sinking sensation in his stomach, but he will probably settle down determinedly, driven on by integrity or a sheer refusal to be beaten. You may adopt either of these attitudes yourself when faced with a problem you do not like or cannot solve. One amusing example of the 'I cannot draw . . .' variety is recorded of a very professional artist – the illustrator Tenniel. In 1871 he was asked by Lewis Carroll to illustrate *Alice Through the Looking Glass*, which he did, though he baulked at one of the illustrations required of him, saying that he could not see his way to drawing the picture, 'a wasp in a wig is altogether beyond the applicances of art'. One feels, of course, that it was not so much that Tenniel *couldn't* draw a wasp in a wig, as that he was acting as a kind of self-appointed editor to Lewis Carroll, and objecting to the chapter in which the wasp appeared. Chapter and wasp in wig promptly disappeared, as a result, yet we know that Tenniel was a man with an imagination fertile enough to illustrate the slithy toves, creatures half like badgers, half like corkscrews, given to building nests under sundials, and with a love for cream cheese.

The moral of our Tenniel story is that it is the attitude, not ability, which determines what one can or cannot draw.

Every artist has his own subject, the thing he loves, and in this we can see how attitude dominates our urge to draw. It is because of this that we have to study our own attitudes when we decide that we really want to learn to draw.

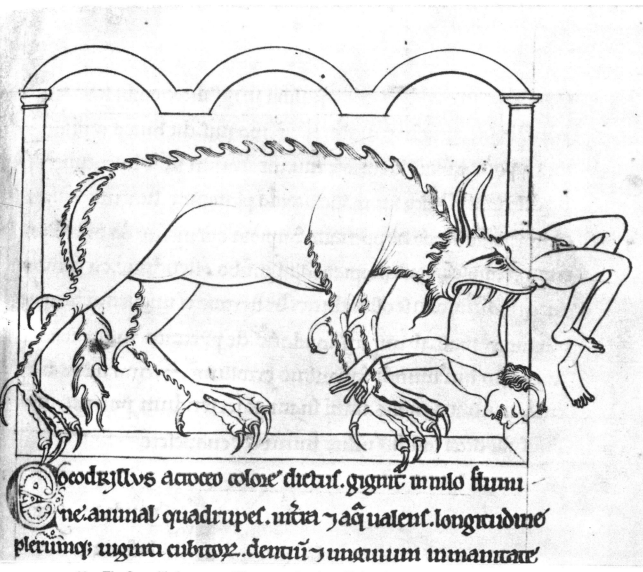

Crocodrjllvs acroceo colore dictuf. gignit in nilo flumi
ne. animal quadrupes. intra ꝺ aꝗualens. longitudine
pleruumqꝫ uiginti cubitoꝛ. dentiu ꝺ unguuum in manitate

88 *The Crocodile* from a twelfth century bestiary. University Library, Cambridge

Drawing is by no means such a simple matter as filling a million sheets of good-quality paper with black lead, it is more a matter of exploring the inner world. And, of course, this is bound up with attitude.

One of the most pertinent of experiments you can make at this stage is to find out whether you draw best from imagination or from life. As I have said, imagination and life are compounded together, too tangled in the basic fabric of our nature to be neatly severed, yet if we leave metaphysics aside, we do find two worlds interpenetrating – the world outside, and the world inside. Visual examples will demonstrate what I mean; we may take the nude by Stevens (plate 48) as representing a study of the outer world, and the drawing of Grosz (plate 79) as representing a study of the inner world.

89 Ford Madox Brown (1821-1893) illustration to Byron's poem *The Prisoner of Chillon* wood engraving. The British Museum

A good example of the artist who would rely on the outside world for his inspiration was Ford Madox Brown, who never drew anything without a careful study of models. He is reputed to have spent three days in a morgue, studying the decomposition of bodies in order to achieve greater veracity in his one dead man in the illustration to Byron's poem *The Prisoner of Chillon* (plate 89). The thing about this picture is not that the dead man is more horrific, or even more realistically 'dead' than other drawings of dead people – those of Goya, for instance – but that Madox Brown felt the need to study from life in this way. He needed the outlet of reality, the contact of the outer world as a prop for his work. Again, he made his studies for his famous painting, *The Last of England* out of doors on a severely cold day in winter so that his models (poor things) would have 'the blue appearance that flesh assumes under such conditions'.

Tenniel, his contemporary, also illustrated poetry, yet he never worked from a model in his life. He drew purely on his own imagination, even for realistic details, since he no more needed to look at the life around him, he boasted, 'than a mathematician would need a multiplication table to work

out some problem!' Perhaps a fairer comparison for Tenniel's 'imaginative work' is with Arthur Rackham, as they both illustrated the same scenes from Lewis Carroll's *Alice in Wonderland*. While Tenniel worked from imagination, consulting a photograph of Alice Liddell (the original Alice) only on the insistence of Lewis Carroll, Rackham felt compelled to work from life in great detail. He actually hired a little girl to pose for his Alice throughout the whole series, and for one particular scene a long table was set up on the lawn of his Hampstead house, the table being set with cutlery from Rackham's own kitchen. His model remembered sitting in a particularly large chair, which was carefully reproduced in the illustration, and she also remembered asking Rackham if he was going to break a cup when he illustrated the scene where the Duchess throws crockery around. Rackham replied that he had already

90　Canaletto (1697-1768) *The Lower Reaches of the Grand Canal, Venice* pen and ink. Royal Collection, Windsor Castle. By gracious permission of H.M. the Queen

broken a few, and therefore knew what they looked like! Tenniel arrived at his illustration by way of imagination, while Rackham arrived at his by way of a detailed analysis and reliance on life – yet there was no fundamental difference between the two illustrations. This only goes to show that it does not matter greatly which of the two worlds you prefer to live in – the worlds of imagination and of reality point very often to the one end.

Obviously, the best way to find which of the two worlds is more suited to your own temperament is to try both. The main requirement for this experiment is that you should *like* the subject you choose to draw – it might be a plant, a car, or a busy street scene, but you must feel some real urge to draw it. Use a pen and draw quickly, working directly from the model. Try to finish the drawing in a couple of hours, involving yourself with the feeling of the scene or subject you have chosen, in the way that Canaletto caught the feeling of the Grand Canal (plate 90). Next you must forget altogether about drawing from life, and you must work from imagination. The subject must be the same as the one you drew from life, but here the connection ends. If

91 Fred Gettings *Organic Landscape* 1968, pen, ink and wash. Artist's collection

92 Fred Gettings, card print of simple shape

you drew a landscape before, then you must try to imagine a very exotic landscape now – perhaps a landscape which is little better than an organic structure (plate 91), or one which is filled with flying dragons, castles, and so on. Perhaps your street scene would be transformed into an imaginative 'reconstruction' like the pen illustration by Robin Laurie (plate 93): it doesn't matter how far removed from reality your imaginative drawing is, provided that it springs entirely from your imagination.

The measure by which we are going to judge the experiment we have just conducted is not the drawings themselves – these may be thrown away if you feel so inclined. The measure is the degree to which you *enjoyed* doing the different kinds of drawing. Did you feel happier drawing directly from life, with the visual stimuli as a crutch for your work, in the manner of Madox Brown, or did you feel happier drawing directly from imagination, without that unfortunate interference of reality, in the spirit of Tenniel? Only you can decide for yourself, and your decision will determine the direction which your work will take.

It is clear that we should conduct one or two practical experiments with the idea of looking into our own imagination. We have already seen something of the difficulty we face in trying to create something new, in trying to pro-

93　Robin Laurie *Street Scene* 1968, pen and ink. Author's collection

duce something exciting purely from ourselves, and our earlier experiments with calligraphy confirmed this. There are only two real ways to deal with this problem: one is to attempt to develop an innocence of vision, so that your drawings seem to flow directly from your subconscious, with almost no interference from the conscious mind; the other way is to accept the weakness of the imagination and to take some crutch to help you along.

There are many devices which one may use to aid the imagination. In the discussion on inventing calligraphic forms on page 12 is a series of abstract symbols (plate 10) which had been made as part of an experiment. These were drawn with the aid of a graphic crutch. First of all I designed a single abstract shape as a card print (plate 92). Then I drew a circle on a sheet of tracing paper and lined a diameter through it. Into one of the semicircles I then traced a portion of the abstract shape. I completed the other half of the circle in a similar manner, using a quite different area of the basic form, and then I painted in the areas with a brush. You may trace the sources of the five graphic calligraphic forms which I evolved by examining this single abstract form. As a practical exercise you might try to evolve five or six such abstract graphics in a similar manner – preferably having invented your own basic graphic first.

94 Fred Gettings, three graphic experiments, 1968, pen, pencil and collage

One other device for evolving abstract figures is to cut up magazines and select interesting areas where the scissors have sliced into the typography or pictures, as in the three reproductions in plate 94. The pen and pencil drawings were interpretative tracings of the accidental patterns left on the word James cut from a woman's magazine. I had drawn the five letters on one side of the magazine, and then cut them out so that the images and shapes on the other side were made entirely at random. When these random shapes were stuck down, the five letters were, of course, reversed, yet they revealed an exciting conglomeration of patterns, textures and details. On one of the letters (the reversed a) you can see the hair and eyes of a young woman, on another (the reversed J) the fragments of a word. If you compare the areas of the collage with the drawn interpretation, which is tied down to an oblong structure, you will see how useful this method is for 'inventing' abstract forms. These designs were used as the basis for lithographic and card prints.

More independent graphic exercises can be set by examining some relatively uncommon object, and drawing a reasonably free interpretation of it. The abstract structure in plate 91, which was partly an exercise in free pen work, and partly an attempt to construct a form which was a 'living landscape', was based on a seventeenth century print of part of an insect's body. You could try similar experiments by constructing an organic form based on photographic enlargements of micro-organisms from manuals on the microscope or on biology. Your work should not be a slavish copy, but a free graphic parallel, which succeeds in uniting the actual technique of drawing with the flow of strange forms in order to catch the sense of 'presence' or 'life' in the object itself. The attitude behind this form of drawing is summed up in the Chinese image, 'a single brush stroke covers a thousand miles'.

While we are touching on the Chinese attitude to experimental work we must make mention of what they call Ink Play (*Mo Hsi*). This is a matter of allowing forms to evolve under the loose calligraphic play of the brush. Perhaps you would like to do a few 'Ink Play' drawings along the lines of my own experiment in plate 10, or along the lines of John Prater's skyscape in plate 95, which he allowed to evolve on his sheet by penning and brushing ink on to rivulets of water. Certainly one of the most exciting of imaginative drawing techniques is that which allows the drawing to evolve from a free interplay between the mind of the artist and the technique he is using.

95　John Prater (b.1947) *The Balloon* from *Sam* written and illustrated by John Prater 1968, ink and liberal wash. Artist's collection.

*But as nature is not only
innumerable as the laughter of
the sea, and mobile as the leaves of
a popular, a correct and complete
record is not within human power.
Therefore one definition of art, and
perhaps the most profoundly true, might
be formulated somewhat thus: 'Art
may be said to be the individual
quality of failure, or the individual
coefficient of error of each highly
skilled and cultivated craftsman in his
effort to attain to the expression of
form'.*

WALTER SICKERT
The New Age 1914

96 Susan Wilks (b.1948) *Nude* charcoal and white conté. Author's collection

Drawing from the nude

By this time you should at least know which end of the pencil to put in your mouth, which means that you are in a position to tackle the most formidable task which ever faces an artist – that of drawing the nude. Working from the 'life', as the nude is euphemistically called, presents a set of problems which have a peculiar fascination for the artist, as most people are aware. Some people seem to imagine that the life class exists because the human figure is somehow intrinsically beautiful, and because all artists would echo the words of Max Burchartz; 'He who loves plastic form loves the figure of the un-clothed human being as the most perfect model'. The human figure is, however, sometimes extremely ugly, and in any case real art is not necessarily concerned with beauty. One must look elsewhere for the reasons for the per-sistence of the life class as an institution.

Before a naked model the artist is faced with a set of problems which he would not have were the model clothed, or were he drawing animals, plants, ships or fish. To draw the nude really well one has to be accurate, and one has to learn to see in a very special way. The important issues in life drawing are involved with the idea of *form,* but not merely with form, for after all a clothed model has a form, and so has an aeroplane or a coconut. The form of the nude is something which is easy to see, to feel, but extremely difficult to put into words: thus, even drawing from the antique, from say a superb Michelangelo statue, life-size and splendid in proportion, would not present the problem of form which we find in a nude living figure. Drawing from the nude is an exercise in discipline involved with the analysis of form and re-quiring considerable technical accuracy and ability to see.

The case for technical accuracy is easy to grasp. If you were making a drawing of a clothed figure, and this involved depicting the flow of drapery around the legs, you would make every serious effort to suggest the solid form of the leg behind the drapery and to indicate the tension of the folds which sheath the form, but it would not matter a great deal if you were not precise within an inch or two in the placing of a fold. With this kind of subject there is no great demand for a precision of handling or accuracy of drawing – these are superfluous. However, if you were to make the same sort of error in drawing from the nude, in, for example, making a leg an inch too thick, or in leaving a knee cap even a fraction of an inch out of alignment, then the drawing would look absurd. If you were drawing a plant and left out one of the leaves, or changed its shape slightly, it would not matter a great deal, but if you drew a nude and left off or distorted one of the fingers, it would look ridiculous. There is a need for accuracy in this discipline of life drawing, that much is evident.

The case for the nude as an instrument which enables one to learn about seeing is not so easy to grasp. Yet until it is grasped much of the purpose of life drawing will remain obscure. One has to learn to see. One has to learn to see the nude figure as it really is; as a series of surfaces regulated by under-lying forms of articulated structures. Then one has to learn how to express these relationships (which we call form) on to a two-dimensional surface.

Claude Monet said that the artist should 'try to forget what objects he had before him – a tree, a house, a field, or whatever' – that he should try to see the essential abstract structure of the form. His contemporary, Cézanne, developed this theme when he wrote, 'one should try to see in nature the cylinder, the sphere, the cone, all put into perspective', and although he was quite right in making this suggestion, he would have been more to the point in saying that we should try to see nature as consisting of *articulating* cylinders, spheres and cones. Yet both Monet and Cézanne point to the value of seeing the nude in the right way: in order to be able to draw the nude one has to see it as an abstract structure composed of articulated forms. It is this underlying abstract structure which is the important thing. Take for example the knee, which is the articulation between thigh and leg, the place where two cylinders meet. We see a surface of skin with modulated facets which reflect the light in different intensities. This is what we see; but what do we *know?* We know that the knee is solid, that behind the skin there is a structure of two bone tuberosities, where the head of the tibia is joined with the head of the femur, that both are protected by the patella, the whole skeletal structure being sheathed in a protective layer of fat and muscle. The more we know about this substructure, the more clearly are we able to *see* the knee, and understand how it works. It is because of this that ever since the Renaissance, ever since a need to describe the outer world scientifically and accurately has been felt, artists have studied the skeletal frame and muscular surface of the human figure as a prelude to drawing from life. With a grasp of the underlying structure the artist is able to read more deeply into the form than the light reflected from a skin surface will allow – he is able to understand the hidden articulation and therefore in a better position to describe the form in graphic terms.

Do a drawing of a leg from life – your own, in a mirror, if you have no model. You aim must be to draw it as accurately as possible and to the very best of your ability. When you have completed this drawing, make a special study of the structure of the leg, preparing a detailed analysis of the skeletal and muscular frame, and once you are familiar with it, do a second drawing of the same leg. A comparison between the two drawings will enable you to see how a knowledge of the inner structure of the leg has helped your drawing of that leg.

Ideally you should attempt a study of the whole of the human form, the skeletal system, and the surface muscles, before you begin seriously to draw the nude. The example of the leg which you have just studied was a fairly simple exercise; if, however, you try to draw the human hand you will see the problem in quite a different light. Here you will see immediately the need for a reasonable familiarity with the skeletal/muscular structure beneath the skin and fat. The artistic tradition holds that if you can draw a hand properly, then you can draw anything!

Even a cursory examination of the naked human body brings to mind Cézanne's dictum, and we see a series of cylinders and spheres, which are harmoniously articulated. We see this writ small in the human hand. After all, a hand is merely a series of bones with muscles and tissues wrapped around them, each finger consisting of three small articulated cylinders. The hand may be drawn in such a simple way if you want to generalize, to study the form: but if you want to particularize, that is to say, draw a specific hand,

then you must examine the basic form of the articulated cylinders and find out how this deviates from the pure form. Perhaps the end of the topmost cylinder (that is the nail phalange) is pointed, or perhaps it is spatulate or square in termination. Perhaps the articulation between the three cylinders is not very graceful, being knotty or deeply wrinkled. Observe how the wrinkles on this particular hand ride around the cylinder form, or how they bunch over the top of the knot or contract into hair-lines as the cylinders bend.

Try doing two drawings of hands. The first one you must do by way of analysis, the aim being to reduce the complex form to a basic element. The second drawing must be just as analytical, but this time you must attempt to record all the particular characteristics of the hand before you.

The progression from simple analysis to the particular statement marks out the graphic process which you will be wise to adopt for all life-drawing in the preliminary stages. One begins by working from the general form to the particular expression of it; sketching in the general proportions and structure analysis, and then working from these down to the individual nature expressed within the structure. A good way to learn to see things as basic structures, especially when you are drawing something relatively large, such as the entire human figure, or a tree, is to half-close your eyes, for this simplifies the forms, narrows the contrasts in lighting, and helps you to reduce them into their component elements.

Many of the inferior manuals on drawing advise the student to rough out the figure before him in linear terms – either as a 'matchstick figure' or as a sketchy outline. This is very bad practice – it serves no purpose other than to indicate the general proportions of the figure on your sheet, and it is quite the opposite of the best way to tackle the drawing, which should be *constructed* on the paper, with every stroke relevant and related to what you see before you, because you *know* about the form.

There are many different ideas about the proportion of figures, ranging from the fairly simple idea, of late mediaeval origin, that the head is about one seventh the size of the entire body, to the more complex teaching which sprang from the nineteenth-century academic ideal figure, and which offers over forty proportions between the different parts of the body of an ideal nude. All such ideas about proportion are based on something which is palpably true, but which is very hard to tie down in words or ratios – that each part of the human body bears a distinctly harmonious relationship to every other part. Whether this relationship is expressed mathematically, in formulae, or visually, by means of geometric constructions, is fairly irrelevant to our own purpose: the important thing is for us to realise that there *is* a relationship between the whole and the parts and that the best draughtsmen always succeed in expressing this relationship perfectly(see plate 99, for instance).

That the harmony of relationships between the parts of a figure cannot be reduced to formal rules is evident to anyone who has examined people. Some people have large hands, some small hands, others are thin, others fat, and indeed although there is a whole battery of systems for classifying the 'types' of people, from the ancient astrological theories to Kretschmer, yet they all flounder on the simple fact that ultimately one is left with an individual who, by definition almost, evades rigid classification. And the function of the artist is to reach through the general to the particular, for as the eighteenth century writer on art George Richardson put it, '. . . there is not two leaves

97 Roundel from the Guthlac Roll *Guthlac casting the Demon out of Ecgga* ink on vellum, twelfth century. British Museum

tho' of the same Species, perfectly alike. A Designer therefore must consider, when he draws after Nature, that his Business is to describe That very Form, as distinguished from every other Form in the Universe'. Proportions and measurements are really matters for the artist's eyes, not for his measuring stick. Sir Philip Sidney once asked the miniaturist Hilliard how it would be possible for an artist to indicate something of the *real* size of a man in a small drawing – how could one tell whether a man drawn six inches high was a giant or a dwarf, or a man of even stature? Hilliard replied that the entire proportion of the figure, and the relationships between the parts would be quite different in the three figures, and that these would enable the discerning eye to perceive the nature of the man depicted.

Marked deviations from the basic proportions, which are sometimes intentional distortions, are done usually to convey a distinct feeling to the figure. Most frequently a large head is intended to portray a slightly ridiculous character, but as you may see from plate 97, the large head of the devil from the Guthlac Roll conveys a sense of monstrosity and evil: its proportion is 1:4. The same proportion on a less hideous face would have conveyed a sense of humour – and indeed this is the general ratio for a cartoon figure. The relatively small head of the saint in the roundel conveys a sense of spiritual grace, of withdrawal from the world: the proportion in this case is $1:7\frac{1}{2}$, a proportion favoured by many religious painters. In a later roundel of the same Guthlac roll we find a drawing where the death of the saint is symbolized, in the manner of mediaeval imagery, by the device of a spirit flying from the mouth of the dying man. This is by no means an 'evil' spirit (the man is a saint, after all), and so the ratio of the head to body is different from the

98 Debora Walker (b.1951) four one-minute sketches from the nude, 1968, coloured chalks

manikin of plate 97. It is in the region of $1:5\frac{1}{2}$, suggesting a highly spiritualised creature in comparison with the demon. The tendency of the artist to change the general proportions in order to convey distinct feelings is worth very serious attention: even subtle changes in proportion may change the whole emotional 'feel' of a figure. The main thing is to ensure that any deviation from the actual figure is intentional, not accidental. There is little room for accident in serious drawing from the nude!

However, first, as the cookbooks would say, you must catch your nude. This usually presents something of a difficulty for those who have no friends who are prepared to pose for them. There are, of course, many art clubs and societies who organize life classes for amateurs, and some art schools run part time and evening courses in drawing, yet even so, good nude models are hard to come by. The most satisfactory solution if you cannot find or afford a nude model, is to draw yourself. This is best done standing at a radial easel, with a full length mirror to your side, so that the whole of the figure may be taken in at one glance, and this with only a short movement of the head.

A second best is for you to persuade a friend to pose for you fully clothed. Here, of course, the problem is that most clothing (if it is good clothing, paradoxically) tends to distort the human form, and especially do brassières distort female breasts. Drawing a clothed figure is an exercise in itself, and in relation to the need to study the nude you may at least isolate parts of the figure – the hands or feet, or even the head, and make drawings of these. The disadvantage here is that the sense of the organic wholeness of the figure may easily be lost, and certainly if you draw too many extremities or too many heads, these begin to take on a special importance for you, so that when

you finally come to draw the entire figure, the sense of the whole is lost, and the tendency is to emphasize one part unduly and even to lose the proportion of the figure. One often finds that professional portrait artists cannot draw the whole figure with any real facility, as their natural preoccupation tends to make them give emphasis to the head and to make it too large in relation to the figure as a whole. You must try to avoid this pitfall if you possibly can.

There are almost no rules about posing the model. I suppose that the main thing is to make sure that he or she is comfortable. A seated pose can be held more easily than a standing pose, and if outstretched arms are required, then it is essential to have a leaning stick to support the limbs. Although you may work sitting on a chair, the drawing board resting on your knees, the most satisfactory working arrangement, hallowed by years of experience in academic circles, is that of working at an upright radial easel, so that your head is reasonably on level with that of the model – which is usually how we experience the human figure in everyday life. The question of how far away from a model one should stand is difficult to answer, and it is usually determined by the space available. However, if you are anxious to study the proportion of the human figure in classical terms, to see the whole figure with a minimum of distortion, you should stand a good way from it. If you stand too close there is a natural distortion, and an emphasis on the acute sense of perspective which is of considerable value if you are wanting to suggest the *depth* of space which a model occupies. Leighton, who was a practised academician, maintained that in order to see a model properly you must stand a good eighteen feet away from him, but in my own experience this is just a little too far. If you are working with the drawing board about eighteen inches away from your eyes, at this distance of eighteen feet the model will be the optical equivalent of about six inches. At ten feet distance the model will be about twelve inches high. A nearer position would of course give a correspondingly 'larger' model, but there will be a tendency for distortion to enter into the viewing of the figure. It all depends on what you are wanting to study. Of course, there is no strict need to make the figure size on your sheet correspond to the figure size of the model, but this is actually a great help in studying the relationship which the live model holds with the drawing: it is useful to be able to look from the model to the drawing without having to make too many optical adjustments.

The question of lighting, of how best to light the model, is complex but a few axioms should make the problems clear. The Victorian Frederick Nash would sketch his subjects at least three different times in one day in order to make sure of getting the best possible lighting. I suppose that from our point of view the best possible lighting is that which allows us to see the form most clearly. It is best not to have dramatic lighting – that is lighting which strongly contrasts the light tone of the flesh with very heavy shadows, unless of course your drawing is intentionally a study in chiaroscuro, in light and shade, rather than in form. *Form* is the real subject of the study of the nude; at least, so far as beginners are concerned. Choose, therefore, the sort of lighting which helps to 'demonstrate' the form: a good way is to have the strong light above and in front of the model, with several weaker lights from either side, for this clarifies the form and reduces the shadows to mere tonal nuances. One good thing about having to make a careful 'finished' drawing of a nude over a period of several hours of daylight is the fact that one has to learn to

dispense with the presence of shadows as a means of demonstrating the form of the model. The sun appears to move, and with this movement the shadows are dragged: the form remains constant, however, and it is this which you should be studying, and attempting to reconstruct on your paper.

The only other serious consideration, short of the problem of actually drawing the nude, is concerned with background. Any object receives its descriptive contours only in relation to the background against which it stands. We see things in terms of contrasts – a smooth white thigh against the rough green texture of a sofa cover; the angle of a shoulder against the white wall, and so on: it is therefore essential that you relate your nude figure to the background. Try to avoid drawing a neatly lined figure standing in depressed isolation against a sea of white paper – try to draw a slice of life which happens to include a nude. Sickert's nudes are a delight to look at, not merely because of the handling of form, texture, light and so on, but because of the way in which each of his nude studies is a little composition in itself. Many of the academy figures of the nineteenth century appear to be in a white hole of nothingness simply because the models themselves were usually placed on a dais against a white background – and it is significant that at the time when this was prevalent, the whole of the art movement was not well integrated with the social background of the times. Your aim must be to relate the figure to its setting, and this very often means that one incorporates into the drawing the easels and figures of the rest of the drawing class.

This would be a sensible point for us to turn to the actual drawing operation. Let us examine a master drawing for a while, in the hope that we might pick up a few hints as to how we may draw the nude ourselves. We will take as our example a good, sensible 'realistic' chalk drawing by Alfred Stevens (plate 99). Naturally, the purpose of this analysis is not to suggest that you should draw the nude in this particular way but to show how a master draughtsman has tackled one or two of the problems which face all those who decide to draw the nude.

It is very probable that Stevens started the drawing by lightly sketching in a soft indication of the line of the back: this is always a sound plan, for the spinal column is the very base of the human figure, and the way in which it rests or reclines on the pelvis determines the essential structure of a given pose. When Stevens made this single line he would have established the size of the nude in relation to the sheet of paper, and the line would have become the mark to which all other subsequent lines would have to be related. It would therefore have been made carefully, with due reflection and seriousness.

So few beginners realise the importance of this first stroke. They will sometimes draw their line with so little thought that when the relating lines (such as those of the legs) are added to it they find the model's toes do not fit on to the paper. Be careful about this first line.

I suspect that Stevens' second move would be to establish the position of the pelvic girdle, for this would produce the first indication of three-dimensional form: even from the beginning Stevens would be thinking of his drawn nude as an interpretation on a flat surface of a solid form – he would not construct a linear figure which could later be 'filled' with shading to suggest form. He would 'feel' with his chalk around the form, across the top of the thighs, and it is therefore not surprising that one can see traces of just such a line following the swell of the form just above the buttocks and around the

99 Alfred Stevens (1818-1875) *Nude* red chalk. British Museum

top of the front thigh, across the back.* Note how Stevens is working by
feeling into the form, by analyzing its structure, and then reconstructing what
he sees on to his flat paper.

He would then very probably continue the line of the belly, midriff and
breasts as one light stroke, measuring the length of this line, and the details of
its proportions against the spinal line. His next step would be either to sketch
in a line of the thigh in order to establish the proportions of the leg against
the spine, and to indicate how the leg balances the pelvic and rib structures,
or to indicate the position of the arms. In either case he would be sending out
exploratory lines from the basic form of the torso, lines which he would be
quite prepared to adjust if they later proved inaccurate. The precise value of
indicating the arms at this point is that they would establish a horizontal
frame of reference for the drawing – a real need since the first two major
lines which bound the torso are verticals. We can see that Stevens made more
than one attempt to establish the *precise* horizontal of the arms, for there are
several 'search lines' still preserved.† It is certainly not likely that the arms
of the model moved while he was drawing: Stevens, having drawn one line
as a tentative statement of the position of the arm relative to the body, found

* Not visible on the reproduction, unfortunately, but quite clear on the original.

† The technical term favoured by most art critics for such lines is a variant usage of the painter's
term *pentimenti*, a word which is unfortunate in the context of drawing. 'Search lines' conveys
the idea more accurately, and with less pretension.

100 Manner of Bartolomaeus Spranger (1546-1611) *Mars and Venus* pen and brown ink on light brown paper, heightened with white. British Museum

it necessary to correct this direction, using the first line as a basis for measuring the precise adjustment required. We also find this superimposition of 'search lines' in the left leg, which Stevens moved backwards a good two inches (in scale to the model) when he realised that his original lines were inaccurate. We see, then, that whether Stevens chose to work upwards, towards the arms, or downwards, in the direction of the legs, his lines were related in either case to the structure of the torso which he had already established. With the torso established, he was able to use it as a base for further exploration of the structure before him.

Stevens had drawn and studied the nude for enough years to make fairly accurate assessments of relative proportions by instinct; he would, for example, be able to draw the correct length of arm relative to the already established length of torso within a few centimetres of accuracy. This ability is largely a question of training and experience, however, and it is a thing which does not come easily to the beginner. There are a few simple devices which one may rely on for establishing relative proportions, and I shall touch upon these shortly, but it should be our aim to draw like Stevens and the other masters, with no need to rely on mechanical devices.

Once Stevens had indicated as accurately as possible the form and structure of the nude – constructing it not merely as a linear outline but as a solid form with a dynamic interaction between the essential structures of rib-cage, pelvis, head, thighs and arms – he could start 'drawing into' this framework to re-feel and correct the form. By doing this he would be able to give greater articulation to the forms, and to lend more volume to the representation of the solidity.

You will no doubt have noticed that Stevens' method of constructing the form of a body is with the aid of lines which follow the form. Note that I say 'follow the form' and not 'indicate rotundity', which is a very different kettle of fish. The use of lines which follow the form is a result of searching out the form itself, as the drawings in plates 47 and 99 each demonstrate. This is not merely a graphic trick which may be learned and applied with ease to each and every nude. You will see, if you compare the drawing in plate 100, which

is in the manner of Spranger, with Stevens' nudes, just how great the difference is between a gimmick for expressing form, and an honest searching for form. As the Spranger drawing shows, the use of form-lines may be crude and mechanical when they do not spring from acute observation and feeling for the actual form. The difference between the two is almost the difference between wire-clamps which bind the form in, and lines which explain all the nuances of the delicate gradations of planes making up the individual form.

Other methods of explaining form may be seen in plates 41, 101 and 38. In Henry Lamb's beautiful nude study (plate 41) the form is expressed mainly by the rich, flowing contour lines (note the many search lines), as the loose parallel shade-lines do not really follow the form, except around the stomach. The function of these shade-lines is more to express the chiaroscuro of the figure than to express its form. On the other hand, Emilio Greco's nude (plate 101) is drawn almost completely without contour lines, and the form, such as it is, is expressed with the aid of strong irregular cross-hatchings. Be wary of this last method, for although it works very well here, it would become rather gimmicky in the hands of a lesser master. Of course, with pen, and even sometimes with pencil, it is possible to convey form, and to enhance the form suggested by the contour lines with the aid of loose washes of diluted ink or water colour. The beautifully loose, casual handling of Josef Herman's nude in plate 38 is a good example of this wash technique. The tendency is for the body of wash to follow the shadow areas of the nude, and for this to reinforce the contrast of light and shade in a distinctive manner. One practical hint about the use of wash with drawing is to try to keep the same quality of handling in the line and in the brushwork – so that if the line drawing is meticulous, then it is best to apply the wash just as carefully. Herman's drawing exemplifies this point very well, for the loose calligraphic ink lines have been supported with loose single-stroke casual brushes of diluted ink.

In spite of the wide variety of methods which are available for describing form, most beginners tend to latch on to the 'wire-clamp' method rather than to make careful study of the form, and to allow the drawing to grow from this study. Yet another tendency is for the beginner to go to extremes with his shading which is meant to indicate form, so that the drawing soon begins to look more like an exercise in the impregnation of blacklead than in the study of delicate form.

Stevens does not merely follow the form with his chalk around the body, as Spranger did; he also follows the form across and over. This may be seen to particular advantage in the work on the back of the nude (plate 99), where one cannot say where the lines end and the shading begins. Study how the delicate line which traces the form of the shoulder blades meets up with the other line which indicates the position of the spine, the two meeting together in a downward curve, and spreading out into one thick chalk area which is both broad and heavy, accommodating both these lines and suggesting the plane of the back as it slants away from the artist's view. Towards the bottom of this broad plane is a series of delicate lines which emerge gently to suggest the form of the back hollow, as it curves in under the bottom of the rib cage. Below this the broad mass of strokes is channelled once more into a single line which describes the rotund form of the bottom.

Observe the wide variety of pressures which Stevens has applied to his chalk as he worked. These transitions from hard to soft, from wide to thin,

101 Emilio Greco (b.1913) *Nude Study for Sculpture* 1954, pen and ink. Victoria and Albert Museum

are not accidental at all, but are the natural outcome of a sensitive searching for form. The variety of pressure which gives expression to a chalk or pencil line is often sufficient in itself to convey the form of a solid body without recourse to internal shading, as the nude in George Grosz's *Athlet* (plate 75) will testify. This kind of richness of line handling is found in the work of all masters. Sometimes the variety in the line is achieved by actual manual pressure, the hand guiding the chalk or pen so as to give a feather touch, or pressing down to a dark structured line. At other times, the contours will be built up from the merging of several lines, of various weights, yet always directed ultimately to expressing and explaining the forms which they contain.

Try drawing a nude using some of the graphic devices which are seen to such advantage in the drawing by Stevens. Try to rough out the structure of the nude as a three-dimensional entity in delicate, tentative lines, following the form as you see it, rather than attempting to establish an outline of what you *know* to be there. Try to find for yourself the important link between the form of the figure in front of you, and the *reconstruction* of that form on the surface of your paper. As you work, whatever the pose your model is in, think back to the points raised in our analysis of Stevens' drawing, and try to apply these principles to your own drawing. Use a variety of pressures on your pencil or chalk, think in terms of sensitive pencil lines rather than in terms of lengths of wire. Work from tentative statements of form to a full exploration of the form: do not be afraid to correct your drawing with search lines at whatever stage your drawing has reached. Your artistic integrity is more important than the drawing itself. Try to be simple – avoid the blacklead stage like the plague: real art is always involved with minimal means of expression. Realize that there is no line there – that you see the 'line' because of the meeting of tones: yet do not hesitate to use line to express this relationship. In doing this you are touching on the mystery, the real mystery, of drawing. And do not forget that your model is alive – that it is drawing 'from life' with which you are involved: do not be tempted to allow your lines to kill the form, seek merely to define it. Your drawing must be an exploration in search of form, not a hunt to bring back a carcass.

A plumb-line is a useful gadget when it comes to life drawing, for it helps the artist establish a system of vertical relationships which facilitate the accurate construction of the figure. A plumb-line is simply a length of string with a small weight attached to it, the weight being heavy enough to keep the string taut when hanging free. The purpose of the plumb is to establish a system of co-ordinates so that these may be transferred to the paper. One hangs the plumb in front of the model, with the line running through the pit of the throat, for instance, and one notes that since the model is standing, the line continues downwards until it passes through the centre of the left foot upon which rests the weight of the model. This means that if you were to trace a faint vertical line on to your drawing paper you would know for sure that in an accurate portrayal of the figure before you, both the pit of the throat and the left foot would have to be on this line. You would note which other parts of the body this same line bisects, and relate these also to the vertical on your paper. If you were to trace in the angle of the clavicle bones and shoulders with the aid of a few deft search lines, estimating the precise angle of the shoulders against the vertical, you would then have a horizontal against which you could measure the position of other verticals. In this way it is

possible to construct methodically a fairly accurate image of the figure. However, the plumb-line should be used only as a complement to drawing, not as the basis of the art: it is a useful aid for checking relationships once they have been tentatively established. One must not lean on mechanical aids for too long – the purpose is not to produce fine, accurate drawings, so much as to learn how to draw.

Another useful mechanical device is that of measuring the proportions of the model with the aid of a pencil. Hold up a pencil or brush as near vertical as possible, gripped in the fingers and held out at arm's length; then use the thumb as a sliding unit to measure off the apparent size of a given part of the model – perhaps the height of the head. In this case the top of the pencil will align with the top of the head, while the position of the thumb tip will mark off the jaw. One then has established a simple unit by which one may measure other parts of the body. You may twist the hand round, so that the pencil points horizontally at nine o'clock, with the thumb at the pit of the throat, and the top of the pencil hanging over the edge of the shoulder, or almost reaching up to it, as the case may be, and in this way establish horizontal units of measurement. With this unit you can estimate the various proportions of the whole figure before you set down your preliminary marks. This method is especially useful for getting a rough idea of the various proportions involved when there is a high degree of foreshortening, for in such cases our eyes play tricks with us very easily.

The aim in drawing the nude, and to a certain degree the aim in drawing almost anything, is to learn about looking and drawing, so that it is not wise to rely on devices and theories. You should so familiarize yourself with the model, and with everything related to it, that the drawing arises spontaneously, as it were, as a part of natural growth, because the problems of form and so on have been completely assimilated in the looking.

All arts lie in man, though not all are apparent. The awakening brings them out. To be taught is nothing; everything is in man, waiting to be awakened.

PARACELSUS

102 Fred Gettings, abstract drawing, study in movement, 1962, pen and Indian ink on buff paper. Private collection

Conclusion

The story is told of a Chinese artist, one Chang Seng-yu, that the dragons he drew and painted were so alive, so full of vitality, that when he put the finishing touches to them by drawing in the pupils of their eyes, the dragons would soar into the heavens, leaving his silk scroll bare. The myth, like all good myths, expresses numerous meanings, but perhaps the most important is that which points to the elusiveness of a finished work of art. There is almost always something insubstantial about a drawing or a painting once it is finished – the *doing* of the thing is somehow infinitely more important than the finished product, so that even though our drawings may not be of a sufficient quality to leap off into another level of being, there is nearly always an element of frustration about the final work – I suppose because we are no longer *doing* it, and being an artist is a matter of doing. Possibly another source of frustration may be that we do not have that ancient magic of Chang Seng-yu, and our lines stay only too heavily anchored to the paper.

Fortunately, however, the importance of art does not lie in the end product – in whether one is left with a picture of a dragon or with a blank sheet of paper: the importance of art lies in the fact that it is an activity, a matter of doing. It is commonly held that this *doing* is a mystical activity which is reserved for the very few – that being an artist is something rare and important – that art is somehow a matter of genius, special ability and so on. The truth is quite the reverse of this: art *is* a mystical activity, of course, in the sense that every human activity is mystical, being ultimately involved with the unknown and with deep metaphysical questions, but art is not the prerogative of the few. Art serves a biological function which is common to all men. I cannot help feeling that Schopenhauer's belief that a man becomes a philosopher 'by reason of a certain perplexity from which he seeks to free himself' is just as applicable to the artist – with the special qualification that we are all artists, did we but know it.

Art is a part of living, and perhaps Somerset Maugham was not far wrong when he suggested that the most perfect work of art might well be a human life. Those natives who had no art forms, and dismissed the whole idea of art as a special activity by remarking that they tried to do everything well, were not far off the point. Art is one of the more practical ways of working out one's inner problems; it is a cathartic act, a practical therapeutic attempt to free oneself of 'certain perplexities'.

All this points to the inevitable conclusion that Art is not an activity involved with end products, with drawings and pictures, but with the actual doing, with the working out of problems. Art is an activity, not an end product – though it must be admitted that our contemporary western ideas about art appear to have lost this simple truth. Fortunately, any artist worth his salt knows instinctively that two minutes doing is worth more than two centuries of talking. Yet I suppose this is why I feel ill at ease when teaching students how to draw, for teaching is so very often a matter of *talking* rather than of doing, and there remains the undeniable truth that one cannot teach art by talking. One may put forward words of advice, intelligent epigrams,

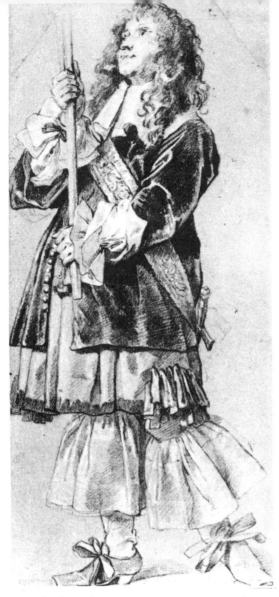

103 Sir Peter Lely (1618-1680) *One of the Sovereign's Canopy Bearers c.*1671, black oiled chalk heightened with white on blue-grey paper. British Museum

even; one may demonstrate, and this is better – but one can never escape the fact that one is not saying, 'This is how you should do it', or 'This is how it is done'; but that one is saying, 'This is how *I* do it'. And, of course, the way *I* do it is not necessarily the way *you* should do it. To tell a modern artist (plate 102) that he should try to draw like Lely (plate 103) would be quite mad – rather like suggesting that our child (plate 3) should draw elephants like Rembrandt (plate 2) – or suggesting to a grasshopper that it should fly like a moth!

After such words, further advice seems almost superfluous, yet I feel that a summary of 'how to do it' may be useful. Professor Grotzinger, in his delightful book on child art, *Scribbling, Drawing and Painting,* sets out what he called 'Ten Commandments' for parents to observe in relation to their children's art. I would like to conclude by adopting ten commandments of my own in the hope that they will help you to understand about drawing and drawings.

1 **Be yourself** Try to draw in your own way. You may copy, or even imitate, in the same way that you may talk about other men's ideas, but the aim should always be to bring you more nearly to yourself, to what is special about you.

2 **Draw constantly** Be prepared to rehearse the world at all times. There is no excuse for not drawing if you want to develop your understanding of art and life. For every book you read on 'how to draw', do a million drawings. That should keep you away from harm.

3 **Remember that art needs no justification** Art is art, nothing more: you need seek for no further justification for drawing than the actual enjoyment of drawing. Most forms of drawing (like most forms of painting) have ceased long ago to have any social importance – the only real justification for drawing must be that you enjoy doing it, or that you *must* do it.

4 **Remember that there are no rules to art** This means, of course, that there is no such thing as 'being taught to draw': there is only the drawing, perhaps alongside a master. No one can teach you how to draw because there are no rules – there are so many ways of drawing. This may be distilled to the truth that there is no such thing as art – there are only artists.

5 **Work in a variety of media** Try to work in a new material or in a new way at least once every week. Do not worry about technique or materials – mess them about; this is what they are for.

6 **Don't worry if you do not appear to 'improve' or if you get 'worse'** If you have such standards, try to find out what they are. As Grotzinger puts it so admirably, 'progress into a new phase of development sometimes looks, at first, like a regression on the old level'. If you think that you are 'improving' or 'getting worse', it means that you have some idea where you are going, so beware. Remember that Picasso defined art as 'a leap into the dark'.

7 **Be thankful for what you learn**

8 **Don't be a hypochondriac** Don't worry if your work is bad: there are no examinations, except self-imposed ones, and if you are a good judge then you are always likely to 'fail'. Keep your 'mistakes' for these will teach you more than your so-called successes ever will.

9 **Learn to wait** You must be prepared to draw for the pleasure of drawing here and now, not for the pleasure of being able to draw well one day.

10 **Be prepared for anything** Realize that every moment is a new beginning.

Index